RUBBER

SOUL

Folk Art and Artists Series
Michael Owen Jones
General Editor

Books in this series focus on the work of informally trained or self-taught artists rooted in regional, occupational, ethnic, racial, or gender-specific traditions. Authors explore the influence of artists' experiences and aesthetic values upon the art they create, the process of creation, and the cultural traditions that served as inspiration or personal resource. The wide range of art forms featured in this series reveals the importance of aesthetic expression in our daily lives and gives striking testimony to the richness and vitality of art and tradition in the modern world.

RUBBER SOUL

RUBBER STAMPS

AND

CORRESPONDENCE ART

Sandra Mizumoto Posey

With photographs by Sue Nan Douglass

University Press of Mississippi Jackson

Photo credits: Michael Owen Jones, plates 7, 12, 32, 37, 38, 42, p. 9; Sandra Mizumoto Posey, plates 1, 2, 29, 30, 31, 39, pp. 12, 13, 28; Tom Nelson, courtesy of *Rubberstampmadness,* plate 5; New Jersey State Museum, p. 9; Old Dartmouth Historical Society-New Bedford Whaling Museum, p.7; Hearts and Hands Media Arts, p. 10; Homeland Cultural Center, p. 17; all other photos by Sue Nan Douglass.

98 97 96 3 2 1

Library of Congress Cataloging-in-Publication Data

Posey, Sandra Mizumoto.
 Rubber soul : rubber stamps and corre-
spondence art / Sandra Mizumoto Posey ; with
photographs by Sue Nan Douglass.
 p. cm. — (Folk art and artists series)
 Includes bibliographical references.
 ISBN 0-87805-902-4 (cloth : alk. paper). —
ISBN 0-87805-903-2 (pbk. : alk. paper)
 1. Rubber stamp printing. 2. Mail art.
3. Rubber Amateur Press Society. 4. Folk Art.
I. Title. II. Series.
 TT867.P67 1996
 761—dc20 96-19083
 CIP

British Cataloging-in-Publication data available

CONTENTS

Folk art has been conceptualized by scholars in several ways. Some have defined it as art created by unlettered peoples, usually limiting it to what is produced by peasants or "primitives." Others have argued that it encompasses paintings and sculptural forms made by those without any formal arts training (who usually do not consider themselves to be artists at all). Still others have viewed it as the traditional material manifestations of a particular culture, often de-emphasizing the role of the individual. In recent years, many observers have broadened the definition of folk art to include any aesthetic behavior resulting in material forms, exhibiting continuities and consistencies through time and space, and learned and manifested primarily via first-hand interaction. Creative rubber stamping, correspondence art, and the works produced by the members of the Rubber Amateur Press Society (R. A. P. S.) do and do not fall within the scope of most of these definitions. Some of the creators have no formal arts training, others have much, and others seek it later. Some describe themselves as artists, while others vehemently deny the categorization. The obsessive collection of commercial rubber stamps aptly reflects contemporary consumer culture, yet these mass-produced items are actually used as tools for individual expression. The practice of these forms (rubber stamping, correspondence art, and R. A. P. S.) therefore is best described by

the last conception of folk art; that is, the artwork and techniques are often shared among individuals or in small groups. Specific aspects demonstrate both innovation and the stability of tradition. Finally, the artists themselves explicitly articulate the need to enact aesthetic behaviors, sometimes in spite of a self-perceived lack of talent.

The use of handheld implements to imprint images and messages is older than writing itself, and, in fact, the oldest known form of writing, cuneiform, was actually a form of stamping on clay. Contemporary stampers often use commercially manufactured rubber stamps; their finished works, far from being mass-produced, recombine images in unique ways and incorporate techniques learned firsthand from other stampers as in any folk art tradition. Correspondence art, as well, is old, pervasive, and often manifested as a folk tradition. Few have not decorated notes and letters with drawings or other forms of adornment or received such items from friends or relatives. The members of R. A. P. S. combine these two forms.

Chiropractor Donna Nassar conceived of R. A. P. S. in the summer of 1992. In this "society," members "meet" once every two months via the individually created pages of an unbound journal. Each of the twenty members creates twenty-one identical 8½-by-11-inch pages of original artwork and text. Placing emphasis on hand-

5

carved stamped images, members adapt a variety of unusual and commonplace materials, from erasers to thin rubber sheets originally intended as stencils for gravestone etching, for the creation of their stamps. Pages are collated by the editor and mailed out to all participants, with the twenty-first copy retained for archival purposes. Member Sue Nan Douglass describes the result as "a moving, evolving, growing exhibition that you continue to do pieces for." Since it began, members have joined and fallen away, with many of the original members still participating. The group consists primarily of California residents but includes members from many other states. While most knew at least one other participant when they joined R. A. P. S., most also know many members only through the journal's pages. The activities of the Rubber Amateur Press Society exemplify how the use of stamps and the creation of correspondence art assert the integral nature of the aesthetic process in daily life and, as well, emphasize the ever-expanding, even global nature of individual connections in the modern world.

My first thanks in this book must go to Kat Okamoto, owner of A Stamp in the Hand Company. When I began working for her in February 1987, I had been a rubber stamp hobbiest for two years. As time passed, my duties in the then-small business expanded from cutting rubber dies to include everything from stamp assembly to stamp illustration and product demonstration. Although I am no longer an employee of A Stamp in the Hand, I continue to work in the rubber stamp industry as a freelance stamp instructor. Over the years, Kat Okamoto has been both employer and dear friend; no one could have been more giving. She proffered endless dinners, chocolates, and movies, allowed me to set my own hours, and, most generously of all, gave me the freedom to create the job I wanted. Her creativity and boundless enthusiasm are an inspiration.

Thanks must also be extended to the participants in this study, my fellow members of the Rubber Amateur Press Society, whose spirit and work inform every page of this book. I am particularly indebted to Sue Nan Douglass for spending endless hours expertly shooting most of the photographs, Bill "Picasso" Gaglione for so freely lending me materials from his archive, Wendy Gault for her generosity, and Donna Nassar and Don Clarke for the continuous organizing efforts that make R. A. P. S. possible. This work has also been aided or inspired by current R. A. P. S. members Julie Hagan Bloch, India Bonham, Judi Donin, Cyndi Fox, Kay Slutterbeck, Cathe Jacobi, Dianne Jenkins, JoEllen Moline, June Munger, Jane Reichold, Susan Riecken, Stephen Sloan, Janet Takahashi, and Vicki Timmons, as well as by former members Larry Angelo, Jon Bailiff, Russell Bloch, Kathryn Cramer, Darlene

Carved stamp image by the author.

Domel, David Evans, Ada B. Fine, Emmy Good, and LaVona Sherarts. Others in the larger rubber stamp community provided invaluable assistance, and I am especially grateful to Roberta Sperling, Rhonda Meyers, and the staff at *Rubberstampmadness*.

Special thanks go to my family: my mother, Akiko, and my sister, Hedy, for their endless support, and my father, Calvert, to whose memory this book is dedicated. Thanks as well to Leslie Scott and Lisa Gabbert for listening, to Dixie Swift of the Homeland Cultural Center, and to Mary Jean Blasdale of the New Bedford Whaling Museum. JoAnne Prichard at University Press of Mississippi deserves considerable thanks for her graciousness and extreme patience. I am also profoundly grateful to the people of the Dorland Mountain Arts Colony and the James Irvine Foundation, particularly Karen Parrot and Alice Sebold, for providing me a peaceful place to work on this manuscript. Of the professors, students, and staff at the UCLA Folklore and Mythology Program I cannot possibly say enough; without them I would never have seen these years of passion and play with new eyes. A few individuals who helped on this project specifically are Michael Heisley, Robin Evanchuk, and Patrick Polk and his wife, Jeri Manulani Williams.

Deepest thanks go to editor and professor Michael Owen Jones, who didn't even blink when a graduate student at the end of her first year had the gall to come to him with a book proposal. Throughout this project and my education, his insights, assistance, and sheer love of the discipline have inspired me, pushed me, and given me hope.

And, finally, thanks to the god Vulcan, without whom we might never have been able to vulcanize rubber. In the words of *National Stampagraphic,* "I stamp therefore I am."

Carved stamp image by the author.

Whaling logbook stamps (showing whale's tail, two ships and two whales).

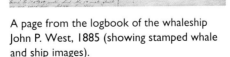

A page from the logbook of the whaleship John P. West, 1885 (showing stamped whale and ship images).

Stamp Art

In the Sixties it was drugs.
In the Seventies it was sex.
In the Eighties it was money.
Who knows, in the Nineties it may be
 rubber.

<div align="right">

Michael Malan
"From the Publisher"
Rubberstampmadness, 1992

</div>

In recent years, image-based rubber stamps have appeared in profusion on the shelves of toy and stationery stores, and these stamps are now found as well in stores devoted entirely to their sale. The largest such stores are probably the Stampa Barbara locations in Costa Mesa and Santa Barbara, which have become meccas to stamp enthusiasts travelling cross-country to reach their doors. Currently, the market supports hundreds of rubber stamp companies, over a dozen conventions annually—from Carson, California, to London, England—and an estimated eight hundred stores across the nation that are devoted to image-based stamps. Annual sales for the industry have catapulted into the tens of millions of dollars.

While it is thus not farfetched to characterize the 1990s as a decade of rubber, it would be incorrect to say that this is the first era in which people have been captivated by stamping, a process I will define as the use of any handheld implement to imprint a message or image onto another surface. In *The Mark of Ancient Man* (1975: 8–9), Noveck states that clay impressed with stamp or cylinder seals has been found in the Near East dating as far back as the late fourth millennium B.C. Clay jars used to store records and other valuables were sealed with these impressions for "identification and probably for security." Often intricately detailed with carved panoramas of gods, animals, and design work, these early stamping implements were highly valued and were sometimes worn as pendants or as a part of the pins that held garments in place (13–15).

In *Thoughts on the Meaning and Use of Pre-Hispanic Mexican Sellos*, Field (1967:5) dates similar seals, or *sellos*, "from before 1,000 B.C. onward." Unlike the Mesopotamian seals that were usually carved from stone, *sellos* were "fashioned almost always from clay." Despite uncertainty surrounding their purpose and use, the *sellos* themselves remain in sufficient quantities to suggest that they were pervasive in pre-Hispanic Mexican culture.

In India, people have stamped designs onto textiles with metal or wooden blocks from the pre-Christian era to the present. Chattopadhyay states in *Handicrafts of India* (1975:46) that today these techniques are "almost as universally practiced as weaving," with each region having its own variation. Most methods, however, fall into one of two categories: pigment applied to the stamp and directly imprinted on the fabric, or the use of a block to apply wax or gum

RUBBER SOUL: RUBBER STAMPS AND CORRESPONDENCE ART

clay mixed with resin subsequently acting as a resist in the dying process. Joyce D. Hammond (1986:260–63) notes that, before the "influx of Westerners into the Pacific in the 19th century," women throughout Polynesia used local dyes and pigments to stamp bark cloth with geometric or naturalistic designs.

Stamps have also been used to make impressions upon food items, most notably bread. In *Bread and the Liturgy* (1970:9), Galavaris describes how stamps made of wood, clay, stone, and bronze imprinted bread for both mundane and Eucharistic purposes among the Christian peoples of Europe and the Mediterranean. The oldest example of such a tool, found in northern Africa, dates to the fourth century of our era (16). In contemporary North America, similar impressions can be found on the bean confections available, among numerous locations, at Mikawaya Sweet Shop in Los Angeles's Little Tokyo (plate 1). In Pennsylvania during the nineteenth century, carved wooden forms sometimes referred to as "molds" imprinted heart motifs onto butter (Schaffner and Klein 1984:72). The design was actually made with a stamping action, in which the mold was pressed into the butter's surface. Typifying the reflexivity commonly found in stamp art, folklorist Barbara Kirshenblatt-Gimblett once wrapped a gift of kitchen accessories in paper that she had stamped with food and utensil images.

An even earlier instance of decorative stamping in the United States can be found in the basketmaking traditions of Native Americans. Judith A. Jedlicka (1982:120–24) describes how the Mission Indians of Massachusetts learned to use a block printing press from the Reverend John Eliot in the seventeenth century and suggests that they adapted the technology for other purposes. By carving designs in tubers, they created stamps that could be dipped into natural dyes and imprinted on splint. Similar techniques came to be used by Native American tribes throughout the Northeast. In addition, stamps carved out of wood were used to imprint bark containers and leather items such as clothing and pouches. Native Americans in the Northeast also made stamps from match bundles, cork, bone, mill spools, and coiled leather.

Seamen of the eighteenth century carved stamps to record sightings of vessels and whales in the ship's log. Stamps were most often carved out of wood and sometimes included a small square in the center of a whale image to notate how much oil was acquired from a given specimen.

In the American West, hot iron brands have been used to stamp marks of ownership on cattle. *The California Brand Book*, the official brand registry publication of the State of California's Department of Food and Agriculture, states that the practice "has been around for more than 4,000 years" and was used by the ancient Egyptians (1987:11). These techniques have also

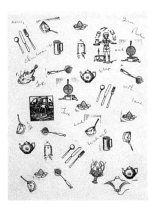

Wrapping paper stamped with kitchen utensils by folklorist Barbara Kirshenblatt-Gimblett for Jane and Michael Owen Jones.

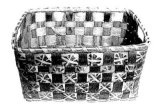

Stamped basket given to Margaret Belinda Crater by Native Americans in exchange for a loaf of bread, probably around 1735.

been applied to humans. In *The Making of Haiti*, Carolyn E. Fick (1990:53) explains that the Black Code of 1685 stipulated that the punishment for unlawful assembly or escape could include branding with the fleur-de-lys symbol upon the shoulder.

While the above examples illustrate the use of branding as a sign of ownership, branding and other forms of body modification have long been embraced by people from various walks of life to denote group membership, express personal identity and aesthetics, manifest supernatural beliefs, or mark rites of passage. In the contemporary United States, African American fraternity members are known to brand Greek letters onto various parts of their bodies. As Omega Psi Phi graduate member Darryl Butler (plate 2) points out, unlike the branding of slaves, "This is a choice. You can choose to have it or choose not to have it. It doesn't make you any less a member of the fraternity if you choose not to have it." Proponents of "modern primitivism" have adopted a similar practice. In his article "Nonmainstream Body Modification" (1992:278–93), James Meyers describes a skull brand being burned into a woman's calf. The brand was created with a bent metal strip cut from a coffee can, which was then heated and impressed upon the subject's skin seven times to properly sear the image. Meyers states that while some alter their bodies to express a rejection of mainstream values, "everyone

involved in the process regarded the new decoration as a piece of art."

Stamps have long been used to make statements that are simultaneously artistic and political. During the mid-nineteenth century, abolitionist Deborah Coates of Lancaster County, Pennsylvania, imprinted a stamp depicting a kneeling slave above the words "Deliver me from the oppression of man" on the center of a quilt. In the same century, the Women's Christian Temperance Union of Ohio collaborated to create a quilt commemorating the Women's Temperance Crusade. Signed on the back by three thousand women, it included the stamped emblems of many local branches of the organization. As Ferrero, Hedges, and Silber explain in *Hearts and Hands* (1987:71), although women of this era could not vote, they expressed their opinions through creative means. These instances have contemporary parallels. Like these women, Vicki Timmons discovered that stamps permitted her to express her political views in a way that was both comfortable to her and effective. By stamping letters to politicians and corporate presidents, she found that not only was she able to make her point quickly and succinctly, but that the letters usually received a personally written response from the addressee. "The imagery has its own vocabulary," she explains, "and it softens whatever you're saying. It spoon-feeds whatever you're saying to the person. It makes it

Detail of nineteenth-century quilt by abolitionist Deborah Coates of Lancaster County, Pennsylvania.

slide down, and there's a joyfulness to it. My most acidic, nasty, horrible, disgusting letter would always get to the heads of companies, always get to the president."

Many artists of note also incorporate rubber stamp impressions into their work. A 1995 exhibit entitled *The Art of the Rubber Stamp (L'Art du Tampon)* at the National Postal Museum (Musée de la Poste) in Paris "places the rubber stamp medium directly in the canon of Modernist Art" (Held and Gaglione 1995: unpaginated). Michael Crane states in his essay "The Origins of Correspondence Art" (1984: 113) that "[t]he use of rubber stamps in the art of this century can be traced to the Russian Constructivists and the Dadaist Kurt Schwitters around the time of World War I, and more recently to Nouveau Realisme, Fluxus, the NYCS [New York Correspondence School], and independents such as Dieter Roth." By the mid-eighties, however, rubber stamps had become an artistic medium used by the general public in massive numbers.

Joni K. Miller and Lowry Thompson's *The Rubber Stamp Album* (1978) helped set off the explosion. In addition to profiling artists who used rubber stamps in their work, the book, which is now out of date, provides a myriad of ideas for using rubber stamps in previously unheard of ways and lists sources where they can be purchased. The authors subtitled their work *The complete guide to making everything prettier,*

weirder, and funnier. How and where to buy over 5,000 stamps. And how to use them. The book's most tantalizing feature proved to be a coupon in the back advertising a yet-to-be-published newsletter called *Rubberstampmadness.*

Now under the aegis of Roberta Sperling (a. k. a. Rubberta Stampling) and Michael Malan, who purchased the publication from Thompson in 1982, *Rubberstampmadness* has evolved from a 16-page newsletter into a 136-page perfect-bound magazine with glossy cover and full-color illustrations of stamp art. *Rubberstampmadness* now boasts a subscription base of twelve thousand and retail sales of eight thousand copies per bimonthly issue. A review of individual issues over the past fourteen years provides a chronicle of the development of rubber stamp art. Far from presenting the simple techniques illustrated in *The Rubber Stamp Album* (however novel they may have been in their day), current issues of *Rubberstampmadness* showcase works that defy the notion that they were created with individual stamps. In addition to these seamless compositions on paper (similar to that in plate 3) the magazine has featured the use of stamps on fabric (plate 5), clay, wood, automobiles and other materials. Other features include profiles of stampers and stamp companies, articles on how to start a stamp company, and advice on how to solve storage problems when your personal collection exceeds one thousand

stamps, as well as the occasional poem sent in by a reader rhapsodizing on the glories of stamping. Regular features include stamp pen pal listings, mail art listings, letters to the editor, and classified ads. The letters to the editor section has been the forum for heated debates over such issues as the legality of selling handcrafted works that incorporate copyright-protected stamp designs and whether the magazine should focus on "cute" or "weird" stamp art and images.

Rubberstampmadness is currently the largest of at least three national publications devoted to the use of art stamps (*National Stampagraphic* and *Rubber Stampin' Retailer* are two others). Smaller independently produced "'zines" such as *Eraser Carver's Quarterly* and *The Rubber Fanzine* also support the public's ever-growing interest in stamps and stamp art.

In addition to making use of conventions, stores, and publications, rubber stampers connect via online computer mailing lists and bulletin board services, most notably Prodigy before its switch from a monthly to an hourly usage rate. Prodigy enabled stampers to communicate and build personal relationships nationally no matter how remote the location of the individual stamper. At the height of its popularity, Prodigy stampers wielded so much power through the rapid dissemination of information that they curtailed business to certain companies by informing other consumers of unsatisfactory service or inconsiderate treatment. Many stampers now subscribe to a mailing list that directs dozens of communications directly to their e-mail accounts on a daily basis. Currently, some of these electronically connected stamping aficionados meet at a designated time during each stamp convention to exchange handmade rubber stamped pins. Scores of pins adorn their shirts and jackets like a scattering of confetti.

Rubber stampers are notoriously self-referential. Many of the pins worn at conventions carry such stamped messages as "Rubber is the Best Revenge," "Summertime is Rubbertime," and "We're not stamping at you, we're stamping with you" (these stamps are manufactured by Museum of Modern Rubber). A popular jewelry item sold by convention vendor Neato Stuff, consisting of a pair of miniature rubber stamp earrings that can actually be used, recalls the ancient seals that were worn as pins and pendants in the Near East. One side of the pair prints an image of a rubber stamp in silhouette while the other prints an illustration of an envelope.

Those who rubber stamp often characterize it as a compulsive activity. Spurred by the frenzy of conventions and the stimulation of works seen in journals such as *Rubberstampmadness,* collectors of rubber stamps rapidly become obsessive. A single purchase of stamps and related supplies at a store or convention booth can amount to hundreds of dollars. A portion of these purchases often remains unused. As India

Rosemary Peterson displays a collection of handmade stamped pins at the 1994 Holiday Original Rubber Stamp Convention in Carson, California.

THIS IS NOT A RUBBER STAMP

DO NOT CONFUSE THIS WITH THE IMPRINT OF A RUBBER STAMP

Stamp images from the Stamp Francisco catalog.

Bonham says, "I [just] feel really good having them." Donna Nassar estimates that her collection consists of approximately three thousand rubber stamps, not an unusually large number for the rubber stamp enthusiast. Betty Harris of Whittier, California, owned approximately seventeen thousand rubber stamps before her death in 1993 (Hall 1994:25). While my personal cache is not as large as Harris's, the dining room of my one-bedroom apartment is dedicated solely to the use of stamps, and my living room coffee table is actually a multidrawer stamp storage unit. Rooms reserved only for rubber stamp storage and use are far from unusual in the homes of stampers: Wendy Gault had a small office in her new house fitted with custom cabinetry for exactly that purpose. Although small, the attic of Vicki Timmons's home in Torrance, California, is densely filled with rubber stamps organized in boxes, drawer systems, and 150 feet of shelving. She calls this haven her "rubber room." She describes endless hours spent there when she first began stamping, sometimes staying up until two or three in the morning. Her husband left meals for her at the top of the stairs. "They seduced me," she explains. "I had a lover here. I had a rubber lover, and rubber lover had such stamina, and would do it over and over and over again, and never said, 'No' and never said, 'I'm tired' but would say, 'Could you clean me up a little, I'm a little sticky.'"

Others also describe the use of stamps in sensual terms. Stamping is an innately physical process. The act of pressing onto a given surface to create an impression seems to have an appeal that goes beyond the attraction of the end result. In *The Magazine Network* (1993:70), Géza Perneczky states that Dieter Roth "was intrigued not by the form of his stamps but rather by the passionate dynamism of their use." JoEllen Moline seems to be expressing this very sentiment when she takes marker to breast and imprints it upon a page, then layers it with stamped designs (plate 6). For their owners and users, rubber stamps appeal to several senses: there is the tactile pleasure of pushing them onto paper, the visual joy of seeing the resulting impressions or of just the stamps themselves (some stampers prefer specific types of stamp mounts, whether oiled maple or acrylic, and will not purchase others), and even an aromatic component—there was once a time when I could identify manufacturers simply by smelling the rubber die.

For many, stamping is not merely a business or a hobby, but a serious medium for artistic expression. In the exhibition catalog *Stempelkunst in Nederland* (1980:7), Ulises Carrion states, "The 'playfulness' that seems to be intrinsic to rubber stamps has actually had a negative effect on the appreciation of rubber stamp art works by the critics and the public."

Stamps have wide-ranging appeal because they democratize and liberate both

Stamp images from the Museum of Modern Rubber catalog.

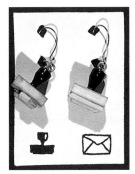

Earrings that double as working rubber stamps, handmade by the people at Neato Stuff.

Vicki Timmons in her "rubber room."

the printing process and the artistic process. Evidence of this is seen in the history of printing presses. As described by James Moran (1973:227–31), when this technology was first marketed to individuals in the eighteenth century, some of the smaller versions were actually glorified stamps. Like their larger cousins, these small units used movable type. Placed in a small hand-held base, they could easily be imprinted on paper. Thus, early on, stamps put the printing press literally into the hands of the people. If Jedlicka's speculation about the Mission Indians is correct, and they developed stamps for decorative purposes *after* learning how to use a block printing press from the Reverend John Eliot, it would demonstrate a similar progression. Liberated from the constraints of a press, stamps could then be used on a wider range of materials. Today, manufactured rubber stamps open up the creative process in a way equally accessible to artists and nonartists alike. Stamping democratizes the artistic process because it provides people who claim they cannot draw with creative tools that ask little in the way of experience or aptitude. For the person who is already artistically proficient, stamps simply become another means of expression. While stamping is repetitive by nature it is also individual: stamps have long been used to make a mark in the world in both literal and figurative senses. From the purely practical use of fingerprints to identify crime suspects to the celebratory

stamping of a child's hands or feet onto birth announcements and plaster (plates 7 and 8), the act of stamping seems basic to the human experience. Ever since someone first placed foot in sand or snow simply to see its imprint, stamping has been a physical and visual act that frees the creative spirit. It is essentially a nonelitist art medium and form, and an "impressive" one at that.

Eraser Stamps

No one knows who first created a stamp by carving an eraser. Folk artists often innovate by adapting learned or observed techniques to whatever materials are readily available, as exemplified by the Mission Indians mentioned above. Eraser stamps correspond to other types of block printing, in which wood and linoleum are used as the printing surface, because artists employ some of the same implements to carve the design. Yet even these tools give way to numerous alternatives. Most carvers use Speedball linoleum blades and X-acto knives, but others mention tweezers, pencil points, embossing styluses, Chartpak Friskit knives, and sharpened umbrella spines. JoEllen Moline, a dental hygienist, once improvised by carving an eraser with dental tools.

Eraser carving differs from other printmaking methods in several ways. First of all, the soft surface of materials commonly used for eraser stamps can be carved more

Image of antique rubber stamp printing kit (from a stamp manufactured by Stamp Francisco).

14

easily. Second, this softer surface lends itself to a wider range of inks. While most block prints can only be created with the use of special block printing inks applied with a brayer, these softer surfaces can be inked with stamp pads and water-based markers. Third, because the brayer is now unnecessary, the narrow tip of the markers enables the printer to apply many colors at once instead of applying one at a time and using multiple blocks to create a multicolored design, although many eraser carvers, such as Julie Hagan Bloch, Donna Nassar (plate 22), and Jon Bailiff, use this latter technique as well. Finally, the softer quality of the material means that eraser carvings are useful as stamps, whereas more traditional block printing materials must have the paper placed on top of the printing surface and pressure applied to the paper with a baren or press. India Bonham explained the appeal of stamp carving over other forms of printmaking: "I really like the immediacy of rubber. I can [carve] it at home, I can even print it at home . . . I don't have to be at class or lug stuff or wear gloves—it's just so immediate. I can just sit and have it right there. It's just so instant and accessible."

The term "eraser carving" is perhaps misleading, since the material used by such carvers is not always an eraser. Staedtler Mars Grand white plastic erasers are widely considered to be the best material for carving stamps; India Bonham calls them "the sensual perfect Staedtler Mars."

Major faults are their small size (approximately 1½ by 3 by ½ inches) and the embossed logo on one side (a recent and much lamented development). In order to circumvent the size disadvantage, many eraser carvers, including Sue Nan Douglass and Don Nelson, link components of a larger image in interlocking puzzle formations (plates 9 and 10) (Douglass 1986:16; 1989:7). In 1989, Larry Angelo and Freya Zabitsky organized a letter-writing campaign to motivate J. S. Staedtler Incorporated to create larger erasers (Zabitsky 1989:21). The campaign was successful in that not long afterward Staedtler created a "carving block" of the same material, this time almost the size of a business card but about half the thickness of the original eraser and without the embossed logo.

The small size and high price (about two dollars per eraser) of Staedtler materials have caused many avid carvers to look elsewhere. Innumerable other erasers have been used, but they are often grainier and therefore less satisfactory. Substitutions include Safety-Kut Printmaking Blocks manufactured by Nasco and a similar but more-apt-to-crumble block manufactured by Dick Blick. Advantages of the Safety-Kut block include low price ($1.25 for a 4-inch-by-6-inch block) and availability in a wide range of sizes, from 2 by 3 by ⅜ inches to 18 by 26 by ⅜ inches. Though grainier than the Staedtler product, it still allows for considerable detail. Another product marketed by A Stamp in the Hand more successfully

rub-ber stamp (rub'ēr stamp), *n.* a device pressed upon an ink-pad to wet its raised rubber characters so that they will leave an impression upon paper or other material; (*slang*), one who, without originality, echoes or approves the opinions or actions of others

Stamp of the definition of rubber stamp from Stamp Francisco.

"Self-portrait with Duck Bill" by Ada B. Fine, from R. A. P. S., vol. I, no. I.

mimics the preferred white plastic eraser in a larger size. Yet perhaps the most interesting material used for "eraser carving" is Blast Mask. A roll 12 inches wide and ³⁄₃₂ of an inch thick with a self-adhesive back, it has a smooth texture and can be carved with detail comparable to the Staedtler Mars Grand. Its thinness, however, necessitates that it be mounted before printing. "Blast Mask," carver Don Clarke explains, is used "when people are making gravestones. You apparently cut out of this stuff with a razor blade the image that you want to be blasted and you peel away everything else and they sand blast it and apparently the sand bounces off the rubber but where there is no rubber it eats through the rock."

Also used for "carving" stamps is a product called Penscore, manufactured by Clearsnap, Inc., and basically identical to children's bathtub blocks. After its surface is warmed with a heat gun, it can be imprinted with any textured item, from leaves to jewelry, or the user may "carve" by drawing on it with a ballpoint pen (thus its name). The finished block can then be inked with pads or markers and stamped; the result is a soft, shaded image (plate 11).

While products are more diverse than the term "eraser carving" suggests, most share the four qualities mentioned previously: a surface that is easier to carve than those on traditional block printing materials, applicability of a wider range of inks, multiple color printing capability with a single impression, and usability as a rubber stamp.

Self-titled "eraser-stamp carving missionary" Julie Hagan Bloch underscored the instant gratification of eraser carving: "It will say exactly what I want it to say and be eloquent or funny or beautiful or whatever, and to share it with somebody, all you have to do is—*thump! thump!*—stamp it and you've shared it. You can share it a lot with very little effort" (List 1987:31).

STAMP CARVER

Correspondence Art

Artistically elaborated correspondence is, of course, not new to the United States. In *A History of Valentines* (1952:8), Ruth Webb Lee states that the tradition of exchanging handmade valentines "in this country appears to have begun during the middle of the eighteenth century." Cards, letters, and folded rebuses were often elaborate, incorporating cutwork, pin-pricked patterns, calligraphy, and illustrations. In the nineteenth century, decorated correspondence was not limited to love tokens but also took the form of hand-drawn postcards commemorating vacations and honeymoon trips (Burdick 1964:156, 200). In contemporary times, the notes and letters of school children yield other examples of similarly embellished work (plate 12). More sophisticated examples can be found on the correspondence of prisoners to their wives, girlfriends, and other loved ones.

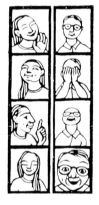

Self-portraits by Julie Hagan Bloch.

16

Using readily available materials such as plain white envelopes, pencils, ballpoint pens, Kool Aid, and shoe polish, incarcerated artists create elaborate panoramas that illustrate their experiences and emotions. As recipient Lorena Trejo explains, "It's like he's composing a love song and he wants me and everybody that sees these envelopes to know that I'm special" (Trejo 1992:6).

In addition to the mailed and hand-delivered specimens mentioned above, new technologies from fax machines to computers continue to expand the possibilities for artistic communication. As Ken Friedman states in *Eternal Network: A Mail Art Anthology*, "With teletext, interactive cable, mailgrams, electronic mail, electronic computer networking, video, inexpensive audio, and—looming on the horizon—myriad new communications techniques, correspondence art is harder to define than ever before" (1995:3). The term "correspondence art" can thus be said to encompass all creative acts of communication from hand-delivered valentines to images travelling over the Internet; the more commonly used term "mail art" is limited solely to that which travels by post. Often sculptural in nature, these pieces travel unboxed and seem to defy ideas of "letter," "postcard," "envelope," and "package" (plates 13–15). Like Trejo, participants in this process often view the object's passage through many hands as part of its appeal. The U.S. Postal Service itself

implicitly acknowledges that the appeal of correspondence art goes beyond philately; cancellations, themselves stamped, often reflect specific themes. Rubber stamps have long been used on mail to commemorate special events, adding public declarations to private communications.

According to some, "mail art" as practiced in the United States by those identifying themselves as artists began with Ray Johnson and his New York Correspondence School. Michael Crane, in his essay "The Origins of Correspondence Art" (1984:85–87), states that "[n]ot only is Johnson the most persistent and prolific of correspondence artists, but his involvement goes back at least to the 1940s. He is personally responsible for spreading the activity, and is considered by many to be the father of the field." As Held writes in *Mail Art: An Annotated Bibliography* (1991:xlviii), the word "correspondence" was often replaced by "correspon*dance*," which was coined by Johnson to describe "the process of interaction derived from the postal encounter." The notion of mailed correspondence as a dance suggests a more lively and directly interactive event than is usually ascribed to this mode of communication. The integration of art into the activity of mailing could well be what allows this perception to emerge.

In time, mail art developed into an artists' network that was informal yet international in scope. Participants in the network contributed to mail art shows

Envelope sent to Lorena Trejo by John "Puppet" Trejo from prison.

Envelope sent to Los Alvarado by Gerardo Alvarado from prison.

17

and maintained personal correspondence relationships. According to Held (1991: xxiv), a few simple precepts are usually considered sacred by participants in the network: "In the middle seventies, the mail art show came to mean 'all work shown,' 'no fees to enter,' and 'documentation to all participants.'" A recent issue of *Netshaker* (May 1994:1), a mail art magazine, or "'zine," published by Chuck Welch, lists sixteen other 'zines published independently by mail artists. Held states that he documented 1,335 mail art exhibits between 1970 and 1985 and writes, "No doubt there were many more."

The appeal of mail art as a form is attested to by the widespread popularity of the *Griffin and Sabine* trilogy by Nick Bantock. *Griffin and Sabine* (1991), *Sabine's Notebook* (1992), and *The Golden Mean* (1993) chronicle the fictional correspondence of two artists who have never met. The books contain actual envelopes bearing richly decorated letters for the reader to pull out and read. Like real mail art, Griffin and Sabine's correspondence fascinates not only because of its visual appeal but also because of the degree of intimacy created between participants who have never met face to face.

In *Networking Currents* (1986:40), Chuck Welch states, "While mail art brings no monetary wealth it offers sustenance and solidarity through sharing ideals of love, hope, trust, cooperation, collaboration and creative gift exchange." Correspondence art, from the mail art show to the 'zine to one-on-one communication, manifests in its multitudinous forms exactly what its participants want and need from it: whether it is an anonymous forum that frees the individual to speak from the heart, a public declaration of affection, or a way to maintain the purity of art by circumventing establishment art channels, it is a way for participants themselves to determine the structure of their world.

The Rubber Amateur Press Society

After the basic concept and title were suggested to her by friend Robert Lichtman, Donna Nassar founded the Rubber Amateur Press Society (R. A. P. S.) in 1992. Lichtman, a member of an amateur press association (A. P. A.) geared toward the interests of science fiction and fantasy enthusiasts, explains that the first A. P. A., the National Amateur Press Association, was founded in 1876. A number of other A. P. A.'s followed. In those early years members often consisted of letterpress operators, poets, and journalists who all followed the standard format of sending a number of copies of a given text to an editor who collated and distributed them to members. John Held, Jr. (1991:xxxiii) states that "the mail art publication, where each contributor of a certain amount of pages receives a free issue," is an established correspondence art strategy.

THE MAILBOX IS A MUSEUM

Stamp image from Stamp Francisco catalog.

Designing R. A. P. S. for those who were "interested in but not necessarily proficient at carving stamps," Donna made a few calls to those she thought might want to participate in the project, who then spread the word to others. Most, however, were recruited for membership at Stampfest, an annual retreat for stamp carvers held at the La Casa de Maria in Santa Barbara, California. Soon an array of hand-stamped art began to arrive in her mailbox (plates 16–18).

People participate in both Stampfest and R. A. P. S. for similar reasons. Stampfest organizer Kat Okamoto explains: "Stampfest is so important because it's a time to stop and play. . . . So that's why R. A. P. S. is so important: because it's a time to stop. . . . I guess what's happening is it's giving me permission to allow myself to play on a more regular basis." JoEllen Moline made a similar point when she described R. A. P. S. as "a vicarious way of being with a group of people who understand. . . . To physically get up and go somewhere. . . . That's hard to get to sometimes. This sort of comes in the mail."

In R. A. P. S., as in other forms of correspondence art, artists often play upon a postal theme by incorporating actual postage stamps and prints of carved designs in the form of postage stamps or postmarks. Julie Bloch took this a step further by carving miniature envelope templates that were then cut and folded into tiny envelopes containing a letter, the en-

tire text of which was printed from a single carved stamp measuring 1½ by 2 inches. The mail thus becomes not simply a means of transmission but also subject and medium of expression. Valentines made in the United States during the mid-nineteenth century sometimes exhibited similar features. In *A History of Valentines* (1952: 34–35), Lee shows two examples of this type. A small handmade envelope was affixed flap side up onto a piece of decorated letter paper. The envelope contained a daguerreotype of the sender or his/her beloved.

Perhaps more important than questions of form, however, is that correspondence artists and R. A. P. S. members in particular share a belief in the power and importance of their work. They perceive these qualities less as a manifestation of the end product than of the work's production and transmission process. As Vicki Timmons stated: "You must be an optimistic person, you must have a hope, you must have a light in your heart if you're willing to invest so many hours when you don't have any of those hours to give, to put images on a piece of paper that isn't brain surgery, it isn't gonna change anybody's life, that isn't going to do anything but give us a vision, a word, an image, that's going to hold our attention for a few moments that you've invested hours in doing. You must have a hope that's going to be with you the rest of your life. You must have an optimism, a belief, that carries you through all this

Miniature postal images made with stamps hand carved by Julie Bloch, from R. A. P. S., vol. 2, no. 3.

muck that we live in if you're willing to go to this length for something so seemingly insignificant, and realize that it isn't so insignificant at all."

Several R. A. P. S. members mentioned one artist in particular, Dianne Jenkins (plate 19), whose investment of time, energy and emotion in her contributions is considerable. The raw intimacy of these pieces consistently inspires admiration and a sense of connection with the artist by other R. A. P. S. members. Kat Okamoto explains: "She can really let us know anything she wants because we don't know her. She can tell us her frustrations or what she has to deal with and we don't have to judge her because we don't know her, but on the other hand, she's giving us all this juicy stuff that kind of to me feeds my soul because it makes me feel like I'm not the only one that has these secret feelings or doubts or thoughts or suicidal thoughts or any of those things—so it's satisfying."

There are, of course, innumerable other means of sharing such intimacies; for this group, it was a passion for carving eraser stamps that initially brought them together. The use of the term "rubber" in the title "Rubber Amateur Press Society" is both significant and enigmatic. "Rubber" refers to rubber stamp, a medium often used in the pages of R. A. P. S., although it is not the primary medium. R. A. P. S. was designed by Donna Nassar to be a forum for those interested in carving stamps. The

stamps she refers to are usually carved not out of rubber but out of erasers commonly made of plastic. What is significant here, however, is not the actual material but the choice of terminology. "Rubber," "eraser," and even "stamp" are ignoble terms with which to identify an art form, and their use indicates a focus upon the playful or mundane rather than the serious or elite. The term "amateur," even though it derives directly from the connection between R. A. P. S. and the history of amateur press associations, carries the same implications, which connect it with the art of the hobbyist and the folk artist rather than of the professional. Some R. A. P. S. members, such as Julie Hagan Bloch, are professional artists with formal training, yet they choose to use these terms to identify their art form rather than terminology such as "block printing" or "relief printing." There is also the pun inherent in the title R. A. P. S.: "press" can be seen to denote printer or publisher but it can also refer to the actual method of pressing a stamp onto paper.

While such terminology is modest if not self-deprecating, R. A. P. S. quickly became a channel whereby members found themselves inspired to create more art, in part simply because of the deadlines. As Donna Nassar herself expresses it: "If we didn't have deadlines we wouldn't have R. A. P. S. . . . That's how it's changed my life, it makes me do art." Or as eloquently put by JoEllen Moline, projects that provide

Carved self-portrait, masked, by Dianne Jenkins.

Carved stamp image by Dianne Jenkins.

20

deadlines "give me a structure, which is good, because then I'm not just farting around." Although, according to current and former editors Don Clarke and Donna Nassar, no issue has ever seen all submissions received on time, general consensus seems to be that the time limitations generate more artistic activity. Many, like Kat Okamoto, found that even if one chose a career related to an art form one loves, the demands and stresses inherent in daily responsibilities could prevent the regular expression of artistic impulses. Despite the fact that R. A. P. S. "meets" only once every two months, the inspirations wrought by the creations of others and the imposition of deadlines are features that have contributed to increased artistic activity among members.

It is not simply the quantity of art that has increased. Almost all participants see their artwork changing in innumerable ways, and this in turn inspires everyone involved. India Bonham went from making isolated carved stamp images clustered on a page to producing integrated works designed specifically to fill the 8½-by-11-inch format (plates 20 and 21). Other artists notice similar growth.

Donna Nassar and Don Clarke:
R. A. P. S. o' D. and the Sphincter Police

When chiropractor Donna Nassar, forty-seven, started R. A. P. S., she wrote, "The hardest thing about being [editor] . . . is the same thing that's hardest for me in all parts of my life. It's the feeling that I'm supposed to know what the hell that I'm doing." Nonetheless, the self-taught carver leapt into the project with both feet. R. A. P. S., she explains, tapped into a life-long desire to put people in communication with one another and to help them maintain connection. Donna recalls the summer between her junior and senior years of high school when she attended a drama camp with students from all over the country. "We were together for three weeks and what I wanted to do the rest of the summer was start a newsletter with everybody and I never did it and I always regretted I never did that; for everyone to stay in touch . . . so when [my friend] Robert . . . [came up with the idea for] R. A. P. S. immediately I thought of that." The members she initially recruited for R. A. P. S. were people whose work she admired, as well as one who admired her work but had no prior experience carving. Some, she noted, were simply those with whom she clicked on a personal level. Still others were recommended by other members. Donna sought to create a "place" where people of similar interests could share through their art and writing. She finds that the results in many ways "totally exceeded my expectations. . . . I see people stretching and growing and shifting what they believe is possible for themselves."

Folk artists are often fascinated with

Self-portrait by India Bonham, from R. A. P. S., vol. 2, no. 2.

Self-portrait by Donna Nassar.

the materials they use to create their work. For Donna, R. A. P. S. was not only an outgrowth of a desire to create connections but also of an early fascination with paper. "As a kid I had one of these little doll suitcases," she says, "but mine fell apart because I beat it up carrying around trunkloads of paper. We had a friend who worked for a printer and [I'd] get all these end pieces of paper and bits and stuff and I would just carry them around with me in this doll suitcase with crayons. Mostly I hoarded paper, but I also did this other stuff [with crayons] too." Many R. A. P. S. members share a similar passion, purchasing a surprising array of papers by the ream.

R. A. P. S. thus combined many enduring interests. Eventually, however, the pressures of a divorce caused Donna to leave her position as editor while she found a way, as she expressed it in one R. A. P. S. issue, "to weather this new phase of the moon." Entitled "R. A. P. S. o' D.," Donna's pages in R. A. P. S. are often gentle self-explorations in words and images. Her carvings are loose, flowing, and jagged (plates 22 and 23). The nude self-portraits that often color her entries reflect her willingness to be vulnerable with the rest of the group. While she admits that she's "really horrible" on matters like the organization of the group's treasury, it was she who nurtured and nudged the group along its first year.

When Donna finally passed the torch to a new editor, it was to an entirely different

animal: Don Clarke, whom Kat Okamoto jokingly named "the Sphincter Police." Always one to take things in good humor, Don proceeded to title his editorial page "The Sphincter Gazette."

As is apparent from a quick look at his artwork, Don loves clarity and organization. His visual representations are clean, tight, and detailed (plates 24 and 25). "The accounting firm of Don, Edward, and Clarke" (his full name, as written on an editorial page of R. A. P. S.) details missing dues to the penny. His method for selecting new members as old ones resign is more a matter of practicality than of listening to his heart: "I go in order of who's on the [waiting] list." He also made a number of other changes to streamline the operation of the organization, including setting up a R. A. P. S. database on his computer and reformulating the deadline structure. Nonetheless, Don has had to keep on his toes to ensure that each issue was distributed more or less on time with the books relatively in the black. Although he writes that "there are times that I've even started to enjoy the challenges of whipping you lolly gaggers into shape," he also admits that at times he "needs a lesson in chaos."

While in high school, Don found that he had an affinity for woodworking, but unlike others who designed and constructed large-scale projects such as bedroom furniture sets, he preferred small, detailed carvings. He considered pursuing these interests professionally, but abandoned the idea

Two self-portraits by Donna Nassar.

22

when the opportunity to do so did not arise. Eventually, he became involved with the Society for Calligraphy, but even his interest in letterforms fell by the wayside when members of his local chapter became more consumed with carving stamps. Once again, his love for intricate carving surfaced.

With R. A. P. S., the appeal of carving is combined with an enduring fascination with the mail. While in elementary school, Don's correspondence with a friend was filled with numerous doodles and illustrations. Don even has his own cancellation postmark; although the fact is not widely known, it is perfectly legal to cancel one's own mail after a mailer's postal permit is obtained as long as all mail is dropped off by hand at the post office. Like mail artists who participate in the "Eternal Network" (one of the names given to an amorphous and ever-expanding "group" of international correspondence artists), Don uses the mail as another art medium. The postmarks, whether haphazardly applied by the postal service itself or carefully applied by the bearer of a mailer's postal permit, become a part of the work. "Something inside me wants to get away with as much as I possibly can through the postal system," he explains. "Maybe it's to annoy them, I don't know. . . . So many things seem to go wrong with mail and I really personally love receiving things in the mail that are out of the ordinary and unusual."

For many years, Don had been employed as a motorhome driver for the film industry. With two years of training in commercial art under his belt, he wanted to find a career path that more fully utilized his many skills, but was uncertain about what that path would be: "I dabble in so many artistic things. I just haven't found what I want to do in my life yet. . . . It's hard for me because so many of my friends, they have careers and they've got families and everything's set in stone for them and here I am the total beatnik type character that doesn't quite know what I'm doing." Oddly enough, it was his organizational work in R. A. P. S. that led the way for a career breakthrough at age thirty-three; fellow member Wendy Gault hired him at Disney as a "traffic art coordinator" to track the art of a creative publishing group through its development and quality control process. Basically, she explains, "he's being the Sphincter Police here."

Picasso Gaglione: Ready-made Artist

"I'm not actually an artist," says Picasso Gaglione, age fifty-one, known at various times as William Gaglione or Dadaland, and as part of performance art groups with names such as Group Rockola, the Gaglione Brothers, Dayglo Dagos, Rockola Twins, Grupo Rocola, the November Criminals, and most recently, the Fake Picabia Brothers. "I don't paint," he continues. "I don't even carve erasers that much."

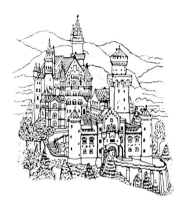

Neuschwanstein Castle by Don Clarke, from R. A. P. S., vol. 1, no. 1.

Carved self-portrait by Don Clarke.

23

Yet for the last twenty-five years, Picasso has found himself irretrievably caught in the web of the international mail art network. In 1967, Gaglione saw the work of Ray Johnson in an exhibition and thereafter began corresponding with the man who would come to be known as the father of correspondence art. Through Johnson, he connected with other members of the New York Correspondence School, an involvement he continued even after a subsequent move to San Francisco, where he still resides. There, while working at an art supply store located across the street from Patrick's and Company (one of several sources mentioned in *The Rubber Stamp Album* and then one of the largest stamp stores in the country), he began to incorporate stamps into his correspondence. Over the years, he used stamps more and more and ultimately purchased a second-hand vulcanizer. Like so many others before and after him, he originally intended to produce stamps solely for his personal use. Wife, business partner, and former R. A. P. S. member Darlene Domel states in an interview with *Rubberstampmadness*, "I married this guy; he said he had a little rubber stamp set that he was using to make stamps for his artwork—and I believed him . . . the fool that I was. Years later, working harder than I've ever worked in my life, for less money than I ever made in my life, I realized we had a stamp business" (Neumark 1992:44). Currently Stamp Francisco is housed in a San Francisco warehouse and is also home to Picasso's other ventures: a retail store also called Stamp Francisco, the Stampart Gallery, featuring the work of artists using stamps as their medium, and the Rubber Stamp Museum, which displays his collection of antique rubber stamps and stamp oddities (including rubber stamps depicting rubber stamps—just the sort of self-reflexive expression he seems to love most).

Picasso states, "I always liked doing stuff in the mail." This activity far precedes his involvement with Ray Johnson and NYCS. He remembers that as a child he drew cartoon-like imagery on envelopes, saying "I think we all did that." He recalls fondly an instance when his uncle punched holes of various sizes onto a piece of stationery printed with the words, "Thank you for your order of fourteen holes." Picasso and his cousins sent these to all of their subsequently bewildered friends.

Picasso's work in R. A. P. S. is frequently of a minimalist nature, consisting of one or two stamped images and a photocopied handwritten note. The images themselves are often from stamps carved by other artists. Seeing R. A. P. S. almost as an extension of his own gallery, he states, "I like to show other people's work. These people in R. A. P. S. know my work, but they don't know these people's work." He is currently compiling an anthology of eraser stamps, which will chronicle the history of their use and feature the cre-

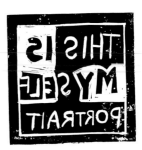

Assigned to carve his self-portrait for Stampfest Summer Retreat 1994, Picasso Gaglione carved "This is my self-portrait" in reverse.

A "Fake Picabia Brothers" stamp.

24

ations of an international array of artists. An underlying thread in all of his pursuits is a love and innate respect for the endeavors of these often-unrecognized artists. In Whitney Otto's 1994 novel, *Now You See Her*, protagonist Kiki Shaw walks into a San Francisco rubber stamp shop "just south of Market Street" (61) and is captivated by a rubber stamped display, which she then purchases for $175. The author's description of the establishment and the display make it seem clear that the setting is Stamp Francisco. Indeed, Picasso recalls an almost identical transaction. Appropriately enough, in the novel, Kiki and the store clerk negotiate definitions of art, artist, and value, which ultimately remain unresolved.

Picasso notes that he once received a complaint about his promotion of other people's art in the pages of R. A. P. S., particularly his inclusion of flyers for upcoming Stampart Gallery shows (plate 26). His response was a hand-carved quotation from that letter stamped and overlayed by another stamp impression advertising an upcoming show at the Modern Realism Gallery in Dallas, Texas, featuring his Stampart Gallery flyers (plate 27). "I thought the combination was funny," he explains. "It depends on who looks at it. One person thought it wasn't really art, another person thought it was." Another layer to the joke, however, was that the quotation was carved by another artist whom he hired. Viewing himself as "more of a conceptual-

ist," Picasso often employs someone else to carry out his vision, particularly when that vision requires hand-carved stamping, a skill at which he is not particularly adept. But the resulting creation, he feels, is still his: "I paid her for it . . . so it's mine . . . it's my art."

Picasso plays with common perceptions about what art is, constantly nudging boundaries as if he expected the boundaries to wink back at him. Through the gallery, museum, and his various writing projects, he strives to promote mail art and stamp art, yet he asserts that it is "because people don't take it seriously that I like it."

In promoting these forms, then, Picasso's purpose seems twofold. He seeks to promote artists but at the same time to maintain the plebeian connotations of mail art and stamp art. "I like the fact that the masses use it," he explains. "I think everyone should do art. . . . With the rubber stamps they can do it." And indeed he seems to take the greatest delight when visitors to the gallery respond to the exhibit with "Oh, I can do that" and then go on to do just that. He might even give them their own show.

With an extensive list of creative explorations spanning decades, it may seem incongruous that Picasso does not consider himself an artist. Mail art, he says, is "communication rather than a visual art. I think the process of communication is more important." Yet he also states, "Art is art.

Image printed from a hand-carved stamp by Picasso Gaglione states "I do not carve eraser stamps."

25

Anything is art. I'm a ready-made artist." He explains, "This is just normal. People should do art everyday. Everybody's an artist; the guy who collects garbage. If I was collecting garbage, I would be an artist collecting garbage."

Kat Okamoto: "Everything I have is out there on my armpit"

Kat Okamoto's rubber stamp odyssey began with the purchase of just three stamps, but soon, she says, "I went into a stamping frenzy and made two hundred Christmas cards and sent them to people I hadn't seen in years, people who had never heard from me. . . . I just was like crazy for this, every week I would . . . buy whatever new ones came out . . . and I just went nuts. So it definitely became a fetish."

As happened with many others, Kat's involvement with stamps eventually led to the formation of her own company, A Stamp in the Hand. She had purchased a vulcanizer so she could make stamps for her own use, but within one year, by October of 1982, she found that she had a full-fledged business. Her frequent patronage of a local store that sold stamps led the owner to ask her to do an in-store demonstration using her new line. "It was the Benihana of stamps," says Kat. Today, the business still emphasizes demonstrations and has grown from a few friends working in the living room of her single-wide trailer home to a fifty-seven-hundred-square-foot factory in Carson with a yearly gross of over one million dollars. A Stamp in the Hand operates two retail stores in local shopping malls, wholesales to retail stores nationally, and sponsors the Original Rubber Stamp Convention, which three times a year hosts over sixty exhibitors and draws an attendance numbering in the thousands. A Stamp in the Hand is a typical example of the inception and growth of a rubber stamp company. Many are much smaller, of course, but many are substantially larger as well.

Such size may at first seem incongruous with the concept of "folk art," yet a careful look reveals that the phenomenon is consistent with other examples. For many folk artists, such as chairmaker Chester Cornett (Jones 1989), Pueblo sculptor Helen Cordero (Babcock, Monthan and Monthan 1986), and Laotian Hmong story cloth artists (Peterson 1988), their work is a primary source of income. Rubber stamp marketing often depends upon firsthand demonstrations of stamping. Techniques for using the products to create works of art are thus developed and transmitted informally among the stampers themselves and between stampers and stamp manufacturers. Stamp company employees are often folk artists in their own right who meet company owners through their frequent patronage and are later hired in some capacity.

Kat herself exemplifies the rubber

Carved self-portrait by Kat Okamoto.

26

stamper whose obsession became an income-producing activity which then led her away from the activity she once adored. As Kat explains, "All of us got into a stamp company because we loved stamping. We were in love with that art and it gave us such pleasure. And very shortly after getting into it there was no time to stamp for ourselves anymore. That's typical." For Kat, participation in R. A. P. S. allowed her to reacquaint herself with the reason she began stamping. "I'm just hungry for that side," she explains, "that art side that I've always been interested in but have never allowed myself to do until now."

Her works in R. A. P. S. now reflect an integration of day-to-day life and the creative process. One submission (plate 28) depicts a recent trip to New Orleans. Its composition, like most of her work, was "totally spontaneous," because, as she explains, "I'm not very good at planning things." The two-page entry includes fragments of text from a vacation journal and photocopied images of souvenir voodoo dolls and pralines that she hand-colored with markers and ink applied with cosmetic sponges. Stamped images include the word "voodoo," dining utensils, and a variety of swirls. Hand-applied sequins and rhinestones complete the work. The inclusion of dining utensils and the image of a praline are significant because, as Kat explains, she was not aware until it was pointed out to her by her traveling com-

panion that her diary had only perfunctory descriptions of visits to museums and historic sights but detailed and effusive descriptions of her meals. Although she tries to carve at least one new image for each R. A. P. S. submission, the utensil stamps, like many of her stamped images, were also used in an earlier piece. Basing her carving on a piece of jewelry, she states that "I seem to get most of my inspiration from my direct surroundings, i.e., my dolls, hangings, jewelry, those are the things I use to carve," but "they don't look anything like this. . . . Then I thought, oh well, they're kind of charming in a sort of ugly way."

The integration of creative pursuits with other aspects of her life that R. A. P. S. has encouraged is evident in a recent letter to a former beau. The ten-page "novella" entitled "Ode to a Wandering Weenie" is profusely embellished with multicolored stampings that emphasize relevant passages with phrases such as "Time wounds all heels" and images such as tanks and exploding volcanoes. "It's as if the collection [of stamps] had been staying there in those drawers, dusty, for like twelve years until this moment," she explains, "and it was one orgasmic moment in stamps."

At forty-four, Kat is beginning to sense the limitations of time and her own mortality. "Everything seems so important now," she explains, "everything seems of the essence." As a result, she searches for what truly holds meaning in her life and has come to find that for her, rubber

"They're kind of charming in a sort of ugly way."

delights rather than disturbs Stephen. He explains that, ever since he started as a street performer twenty years ago, "I've always had this ethereal quality to my work: show up, do a show, leave. I like that. I'm really into live performance."

Perhaps unlike some others, however, Stephen finds no appeal in the marginal aspect of the rubber stamp subculture. Many, he finds, think "we're rubber stampers, we're really weird." To which the professional yo-yo artist, flame swallower and American portraying a Dutchman in Japan says, "Get a clue. I'm sorry, but you're not even close to what weird really is."

Stephen does feel a bond with other members of R. A. P. S., however. Like others, he has a zeal for the form (plate 34), which leads him to become, in his own words, "an eraser-carving evangelist," and he stated that he felt "a real strong connection with the group as a unit." Nonetheless, he goes on to say: "There's one phrase that goes through my mind every time I think of doing my R. A. P. S. page: 'The cheese stands alone,' from the 'Farmer in the Dell' song. . . . In the end after the farmer takes a wife and all that kind of stuff, one person's left [as] the cheese in the middle of the circle of people playing and everybody says, 'The cheese stands alone, the cheese stands alone.' Not that I consider myself an outsider or anything, but I really think of my page as freestanding."

Sue Nan Douglass: "When the student is ready, the Stamp Masters will come"

Sue Nan, fifty-six and formerly a registered nurse, is a self-taught carver who, around 1973, began carving potatoes for the purpose of making Christmas gift tags. Potato printing is a technique she remembers from an early age when she watched her mother, a kindergarten teacher (to whom she also sent notes doodled with various illustrations). Because of the potatoes' lack of longevity, as an adult Sue Nan attempted to work with linoleum block, but she found the process tedious.

Seeking other materials, she began experimenting with erasers, starting with a green Rub-Kleen and finally settling upon the Staedtler Mars Grand. Of herself she says only, "I think I'm a minor artist on some small level. I don't see myself as an artist in the grand scheme of things, but I like to do art. . . . It's the most important part of my identity, it's the part that is most me, more than any other part."

Yet there are perhaps two people who are most responsible for spreading the word about stamp carving: self-proclaimed "eraser-carving missionary" Julie Hagan Bloch and Sue Nan, who wrote articles and taught innumerable workshops on the subject. Oddly enough, writing in her first R. A. P. S. submission that "[w]hen the student is ready the Stamp Masters will come," she was referring to herself as the

Tattoo image from the Hubba Hubba Rubba catalog.

Rubberman image from the Hubba Hubba Rubba catalog.

student and those on the initial R. A. P. S. roster as the masters.

Around the same time that Sue Nan was first exploring carving erasers in 1975, she began studying calligraphy and joined the Society for Calligraphy. Workshops sponsored by the society regularly consisted both of novices like her and of those who had been studying for many years. The workshops inevitably concluded with a critique session in which her own work would be lined up side by side with that of far more advanced calligraphers. Initially, her letterforms looked terrible to her, so she began adding hand-carved stamp images as "illumination" to "detract attention."

Although she studied calligraphy for ten years and is still a member of the society, eventually "the carving became foremost and the writing receded." She often felt inadequate about her calligraphic work. Even now, she states, "I'd rather see handwriting than bad calligraphy." With carving, on the other hand, she felt there was no way to fail. Her eye for layout, however, was a direct result of those years of doing calligraphy, as is her penchant for listing (plate 35). For Sue Nan, the joy in the creative process is in searching for these words and images, building her work on scraps of inspiration from a variety of sources until she exhausts a particular theme.

Another example of this is "CHAIRS, CHAIRS, CHAIRS, AND NO TIME TO SIT" (plate 36). Sue Nan, a collector of antique American furniture, particularly admires chairs: "They have a presence and a dignity about them. You can't ignore them because they're not passive; they kind of offer an act of invitation: stop and rest here. I'll hold you while you eat, read, write, converse, think. Chairs are interesting things—they're kind of architectural, kind of made in our image, they have arms and legs." With this piece, she sought to "honor chairs because I feel like we take them for granted." She favors chairs that are "more structural . . . handcrafted and hand carved by early craftsmen." In part to reflect their hand-carved appeal, she decided to show her own carving process in the finished work. Sue Nan carves with Speedball linoleum carving tools, using the #1 and #5 blades. After transferring the pencil-drawn image onto a Mars Staedtler eraser by rubbing the graphite onto its surface, she carves the outline and fine detail using the narrower #1 blade. She then outlines the image again with the narrow blade in order to create a wide margin. This margin protects the image from sudden slips of the hand while she clears away the surrounding area with the wider #5 blade. Sue Nan achieves the exacting precision of her images by carving while viewing the eraser through a magnifier light. She carves small dots by poking the surface of the carving with a sharpened pencil.

Carved self-portrait by Sue Nan Douglass.

Sue Nan reflected this process in the finished piece by photocopying a collage of early sketches and stampings of each image at various stages in its progression. The decision to include these was influenced by a comment made by fellow R. A. P. S. member Larry Angelo in an earlier issue: "Sue Nan is highly perfect. For one issue, I wish she would not compose a beautiful page, but gather up 21 scraps for R. A. P. S., rough drafts, out takes from other projects. . . . One never sees the process of her work." Sue Nan agrees. "I am too neat and that really bothers me about my work and at some point I want to cut loose and get a little bit crazy but I always do these things that kind of have this pristine quality; I'm not necessarily that way and that's not the kind of art I'm drawn to but that's kind of what I keep spewing forth." Even the disarray of the scattered images was carefully planned: images were waxed, then arranged and rearranged until she was pleased with the result.

To ink the chair images on the top of the page, she selected the colors of wood and an "old green" she had seen on many chairs. She applied ink to the carved stamps with Marvy water-based brush markers. She shaded the second chair to the left by first laying on the lighter yellow color and then touching the edge of the cushion with green. She thought that the stamped images would look best on white but decided they needed to be backed by a paper "that kind of harmonized with those colors." She admits that, as a calligrapher, she finds it difficult not to complete a layout with text. She wrote or printed random thoughts on chairs and a list of chair types on white paper, then waxed it onto the collage and photocopied it onto the brown paper. Many chair images remain in her file, and she states, "I've just begun in chairs; I have a lot more chairs in me to do" (plate 37).

Before joining R. A. P. S., Sue Nan found creative inspiration and camaraderie in the Ventura regional group of the Society for Calligraphy. Those people, she explains, formed "a very close-knit group . . . for probably seven years." A death and a subsequent series of moves shook the foundations of the group "and then it all fell apart." For several years, she says, nothing took its place. When R. A. P. S. was formed, it filled "a need to connect with like-minded souls." Oddly enough, R. A. P. S. came at a time when she, like JoEllen, was "facing time" and was perhaps too busy to meet with a group on a regular basis as she had before, since she had in the interim opened a store called Paper Post. Located in Agoura Hills, the store sells stationery, gift items, and, of course, a large selection of rubber stamps. The business kept her so busy that she often had little time for art and says that she needed "a project that would force me to produce." But while it forced production it was also "a way to regain creative communication." That communication, more than

32

anything else, has sparked growth in her work.

After receiving the first issue of R. A. P. S., Sue Nan wrote, "I carried it around with me for days on end. It felt ALIVE—like a living breathing collective journal of artistic souls." At one point she asked herself, "Will I still be doing this when I'm eighty?" She quickly replied, "If it's still going I'll be in there. . . . I love this thing."

Wendy Gault: Getting the Willies

When Wendy Gault first came to Stampfest Retreat, she very nearly turned right around and drove back home (plate 38). A friend who had convinced her to come along on the trip had dropped out at the last minute due to unforeseen circumstances. Wendy mustered up the courage to continue on her own, then realized she had forgotten all her clothing. With some encouragement, the novice stamp carver remained.

For Wendy, who had never considered herself artistic, commercially produced stamps opened up a way for her to "make beautiful pictures without knowing how to draw." Even as a child, she loved any school craft project that facilitated repetition (such as potato prints or stamps made from cut pieces of inner tube glued to a block of wood). At first, carving erasers intimidated her because she thought it meant she'd have to draw. Nonetheless, she tried

her hand at it in order to make stamps with phrases that were otherwise unavailable. Negotiating a painstaking process of carefully drawing letters onto an eraser backwards, then gouging away at the forms with an X-acto knife, she found she had a certain knack for carving letterforms. Then, she says, at Stampfest, "When I saw Sue Nan carving that first day with a linoleum carver, a light bulb went on over my head in a big way." The tool, with its shovel-like blade, was much easier to use than an X-acto. Sue Nan also showed her she could transfer the design onto an eraser by drawing it on tracing paper and rubbing the leaded side down, thus eliminating the need to copy it backwards. "All of a sudden, I was very interested [in carving stamps]." With these tools in hand, Wendy finally decided to try carving images: "I could trace things off already existing art and be able to make something really nice that no longer looked like the thing I had traced, which was fine with me. . . . The fact that when I traced it it changed and then when I carved it it changed . . . those two generations made it mine as far as I was concerned. Even though I took it from something else I could feel good about it."

A marine biology major at the University of California, Santa Barbara, she worked for many years teaching and designing marine education programs for children and adults, first through the Los Angeles County school system and then through the Roundhouse Marine Studies

Self-portrait by Wendy Gault.

33

Lab in Manhattan Beach. When this ceased to be fulfilling, she entered another line of work entirely as a sample technician for Mattel Toys, a job that required her to design displays for Mattel products. "That was hysterically fun," she says, "that was someplace I got pats on the back for being creative." Later, she was promoted to Mattel's merchandising and planning departments, eventually returning to school for her M.B.A. Now thirty-nine, she is a project manager for a creative publishing group at Disney, where she helps coordinate art development and manages quality control for all books licensed or produced by the company.

Through these jobs, she explains, "I started to connect on the fact that I was a creative thinker; not necessarily in an artistic way . . . but when I did my job, whatever jobs they were, I always found some way of doing it . . . that turned out to be easier, more efficient, more effective." Perhaps for this reason, she views what she does in R. A. P. S. as "just another outlet for my creative thinking rather than art."

When asked to join R. A. P. S., she "felt like the infant of the group." In her first submission, she wrote, "Living up to this new commitment to all of you has given me the willies." It wasn't until she had participated in several issues of R. A. P. S. that she felt she could say, "Gee, I'm not too bad at this and I actually decided that it wasn't so much the images that I created but my method of carving is where I felt I

was more artistic." She explained: "I am very particular about how my lines go and everything has to flow and I decided that's what my art is, not the image I end up in the end with but how I carve the rubber away." This is evident to anyone looking at her finished stamp; the negative space that will not print is filled with eloquent, fine, flowing lines.

It is when she carves that she feels closest to her "essence," which she defines as "thinking about nothing else but what you are doing." Her earliest childhood memories center around the image of her parents walking into the room she was in and the undiluted joy she experienced at that moment: "Your whole being is just ecstatic." Wendy feels that in most cases, "We forget how to get there because you're not really trained to be able to stay there as you grow up." As a result, it becomes all too easy to get swallowed up in day-to-day pressures. "I will spend twenty-four hours at work if something doesn't drag me away," she says. Yet by carving stamps, or even thinking about carving stamps, she can return to that state of joy: "I can be anywhere and I think about ooh, what should I do for my next design. I can be driving in a car. I can be at work . . . and I start thinking about what my next piece is going to be and I'll start getting that feeling."

A strong draw for her to continue her participation in R. A. P. S., however, is the connection she feels to other members,

34

many of whom she knows through Stampfest and others only through the journal's pages. "I think of myself as being close to them through the art and through the writing," she explains. "I care about these people." The combined draw of her own artistic growth paired with this connection led her to start another group, Raplica (the term was originally used as the title of a R. A. P. S. submission by Don Clarke). India Bonham also started her own group, Radio Rubber. Both explained that they felt the need to participate in a project like R. A. P. S. more than once every two months. Wendy also wanted to provide others with the opportunity to experience what she had. "I like to surround myself with people I like," she explains, "which I know is a bizarre concept but it works well."

One of the people she likes is fellow R. A. P. S. member Vicki Timmons, whom she met her first year at Stampfest. During their first conversation, they talked about vacationing in Idyllwild, California, as Vicki took her out to a nonfunctioning fountain in an isolated location on the grounds of La Casa de Maria (plate 39). Vicki told her that the structure of the fountain was a symbol of femininity: "She lay down on this thing, and it was exactly her height . . . it was just phenomenal . . . water comes in the top and it goes around the spiral and it goes out and the symbol of the snake is reproduction."

The conversation, particularly the por-

tion about Idyllwild, inspired Wendy to have a long talk with a beloved aunt who had shared time with her there when she was young. Shortly thereafter, her aunt passed away unexpectedly from heart failure.

"Basically I decided that Vicki was a very important person in my life because of our [first] conversation," Wendy says. "I never would have had that conversation with my aunt and my aunt was a very important person in my life when I was growing up. She nurtured me." Vicki, she explains, like her aunt, is helping her to "understand what feminine is and appreciate it." In honor of this and their friendship, Wendy carved an image similar to the one in the fountain. The resulting R. A. P. S. page contains both Wendy's stamp and Vicki's response (plate 40).

But Vicki is not the only R. A. P. S. member to recognize Wendy's value. As Larry Angelo once wrote (plate 41): "Where would we be without Wendy Gault? Not here."

Vicki Timmons: There Goes Vicki Vulva

When JoEllen Moline saw Vicki Timmons at Stampfest '94, the first thing to fall out of her mouth was "there goes Vicki Vulva." She has no idea why she was compelled to say it, but it is, for better or worse, the kind of reaction Vicki inspires, and Vicki is usually delighted. Laughter erupts out of

her, falling somewhere between a cackle, a chorus of crows, and the chortle of a tickled infant. Describing herself as "forty-three, female, menopausal, cronish, . . . my breasts are 36 long . . . a Californian for-ever," Vicki is someone whose presence is difficult to ignore whether she is stand-ing before you or radiating out from a R. A. P. S. page.

Unlike many of the other members of R. A. P. S., Vicki has been pursuing more traditional forms within the visual arts for most of her life. At sixteen, she studied by copying paintings acknowledged as master-pieces. In her twenties, she was commis-sioned to do a number of children's murals at a library where she worked. A few years later, toward the end of her time with the library system, she stumbled upon rubber stamps while putting up public notices on the bulletin board of her branch library. A flyer led her to a lecture on carved stamps given by Sue Nan Douglass at the Brand Library. While she did not immedi-ately take to carving, soon thereafter Vicki found her creative energies focused almost entirely on the use of commercially pro-duced rubber stamps. "Every single atom in my body was vibrating," she exclaims. "Oh yes, yes! . . . I still remember being totally dumbfounded. . . . All of my energies to creative work went into how to put those produced images together." Thus, while many like Wendy found in rubber stamps a way to be creative even without the ability to draw, Vicki saw in rubber stamps simply another way to be creative. Playing with her ever-growing collection of stamps for "hundreds of hours on end" she found that "eight hours would go just like that."

Eventually, she realized that her new-found love was costing an exorbitant amount of money despite the deceptively small increments. She recalls looking at the 150 feet of shelves on her wall filled with stamps and thinking, "There's a very nice car hanging on that wall right there. I needed a car and there it was." As a result, the "recovering stampaholic" quit purchas-ing stamps. She said the subsequent experi-ence of working at a stamp convention was for her "like the alcoholic going and work-ing in the bar; I'd smell the rubber. I'd walk through and see the glazed look on the rubberhead's face and I'd go ah, I used to be like that . . . I remember that high. I re-member the hangovers from too much rubber and the sore arms from stamping so much and I'd remember my hands would be all stained; I'd have the rubber look." Eventually, the pressures were just too great and Vicki bounced gently off the rubber wagon. She still buys an occasional stamp, but has her habit relatively under control.

What was the appeal of stamps to an artist who already had the tools with which to communicate visually? Like others in R. A. P. S., even as a child Vicki was fasci-nated by texture and repetition. While in the fifth grade she made drawings on onion skin typing paper from her mother's office:

Self-portrait by Vicki Timmons, carved for R. A. P. S., vol. 1, no. 1.

"I liked the texture of it; see, I was into weird paper [even] back then." She duplicated her work by drawing with dark graphite, then rubbing the finished image face down onto another sheet of paper. Yet beyond even the repetition of images or the textures of paper, her later experiences with rubber stamps had another appeal. "There's something sacred in it," Vicki explains, "in using your hand to reproduce. It's the stamping, the physical act of doing that and putting that with your written work that totally expands the possibilities of communication." Thus the appeal is not simply in the image but also in the almost sensual act of pushing it onto paper.

As much as her creative energies were liberated and given new life by stamping, Vicki found that in recent years her artistic work had reached an impasse. But when she saw the work of the collective, she wrote in a letter to Donna, "Other recesses were gently probed and nurtured and excited and left glowing by the work of other artists." R. A. P. S., she wrote, "was where I had all my major breakthroughs. . . . It was in R. A. P. S. that I found edges and pushed them. . . . R. A. P. S. broke into my yet untapped creative energy in the most painless way. I thought I was just meeting a deadline every other month but I was in truth grabbing a lifeline."

Vicki has seen the effects of R. A. P. S. in many areas of her life. Through R. A. P. S. she has explored topics that range from the absurd or silly (plate 42) to deeply painful personal experiences (plate 43). She is again painting, considering art as a career for the first time in her life, and finding that it was within her all along. "Let's put it this way," she says, "God spoke to me in my heart and he said rubber stamp and my heart went b-boom."

A Community via Post

"They're the dreamers," Vicki states of her fellow R. A. P. S. members. "They will keep the hope alive that life is joyful, that there is joy here no matter what. . . . [By participating] we get the reward of work coming through the mail, but it's so much more than that." Vicki and others hint that something deeper than simply an exchange of art drives their continued dedication to R. A. P. S., but what is it? Reaching out across distances, their limited but undeniably meaningful connections with one another shed light upon the nature of human relationships and the construction of community.

Victor Turner's concept of "communitas" as delineated in *The Ritual Process* ([1969] 1977:125–32) is useful for understanding the idea of community and its essential features. Turner uses the term to refer to an egalitarian sense of union that occurs during a liminal state when the individuals concerned are torn away from the usual societal structure of their day-to-

day existence. "For me," he states, "communitas emerges where social structure is not." He suggests that a sense of human fellowship arises out of this liminal place where societal structures are, for a time, broken down and abandoned. In the case of the larger worldwide mail art network, three basic "rules" (no fees to enter, all work shown, and documentation to all) ostensibly break down structure, which however is inherent in the very fact that there are rules at all. Here, the presence of an alternate structure, not absence of structure, gives rise to feelings of union and community.

Turner states that groups exhibiting the strongest sense of communitas all share a common quality: they "1) fall in the interstices of social structure, 2) are on its margins, or 3) occupy its lowest rungs." It is easy to see that, as those who denounce established art circles, many correspondence artists are outsiders and as such bond with one another. As John Fiske states in *Understanding Popular Culture* (1989:24), "[A]ll social allegiances have not only a sense of *with whom*, but also of *against whom* [italics his]: indeed, I would argue that the sense of oppositionality, the sense of difference is more determinant than that of similarity, of class identity, for it is shared antagonisms that produce the fluidity that is characteristic of the people in elaborated societies."

Communities may thus form in opposition to another group, though their sur-vival may later be contingent upon the minimization of these very oppositional factors. R. A. P. S., however, demonstrates neither stringent opposition nor fully assimilated cohesion. There is an element of rejection by and of the larger social system, but members seem to be characterized by normal interaction in society for most of their daily lives and by physical isolation from one another. R. A. P. S. members have said that their activities generate a tangible sense of community, but can such a thing as community exist within the bimonthly, mail-only constraints of the R. A. P. S. format?

In *American Folklore Studies* (1986:109), Simon J. Bronner states that while "[c]ommunity had been viewed as units of time and place, more works . . . revealed that the sense of community was a state of mind, a feeling of people about themselves." Yet even members' own descriptions of their relationships with others in R. A. P. S. do not fully support the idea of the organizational entity as a close or cohesive whole. While Donna Nassar feels that R. A. P. S. offers "an opportunity for an intimacy," she adds that, in regard to some of the members, "I don't really feel very close to [them] or feel like I have strong contact with [them]." For the most part, R. A. P. S. has created very few relationships outside of its format. Those who knew each other previously continue to interact as they had before, while very few who did not know one another before the **38**

inception of R. A. P. S. seek further contact. Regardless of the lack of outside interactions among members, some characterize their relationships with others via R. A. P. S. as "close," "intimate," or between "good friends." Sue Nan Douglass explains: "I have a kinship with them even though I've never met them face to face." Don Clarke even describes the group as "a big family spread out all across the United States," despite the fact that he also feels that communicating once every two months is "enough" and says further, "It's not like we're friends, we're friends in a way, we're acquaintances." When asked to explain this seeming contradiction, Don said that he communicates with the members of his far-flung biological family "probably as much as I communicate with people in R. A. P. S." While it is evident from his comments and those of others that the relationship among members is simultaneously distant and intimate, Don considers "it kind of like a family because we've all learned things about everybody. It's not like somebody off the street you don't know anything about. . . . It's not a tight-knit family by any means; every family has their good points and their bad points, some weird uncles and some wonderful aunts, and I think that's true with our group, any group."

Yet there must be some tie that would explain the commonly articulated sentiment "I care about these people." In order to bond as a community, members some-times create a context whereby they feel that others are in some way willing to experience a degree of vulnerability akin to Turner's "liminal" state. This is demonstrated by the frequently articulated sentiment by several R. A. P. S. members that they feel the closest to Dianne Jenkins, despite the fact that she is one of the members fewest of the others have actually met. For the others, it is "through the art and through the writing" that they become vulnerable, even if nothing explicitly reveals sensitive personal issues. Most members seem either to feel insecure with regard to their position in established art circles or, like mail artists, to denounce those circles altogether. For those who don't feel accepted by the larger art scene, the very act of creating and sharing art is an act of courage and vulnerability. Whether the community consists of artists, scholars, or the members of a particular ethnic group, all face the potential of being misunderstood, perhaps even mistreated, by outsiders.

Regularly, though not necessarily frequently, occurring contact also seems conducive to the creation of community. As both Don Clarke and Donna Nassar pointed out, it was the regular contact with a relatively stable group of people that allowed them to feel a sense of personal connection with the rest of the group. Although India Bonham and Wendy Gault started their own versions of R. A. P. S. because they felt bimonthly contact was

insufficient, most felt otherwise. As demonstrated by communities of classmates, reunions can take place as infrequently as five or ten years apart and there will still be a sense of camaraderie and communal identity maintained among the individuals concerned. In these cases, isolation from others in the group does not preclude the formation and maintenance of ties.

But why was it necessary for R. A. P. S. members to create a community over such distances? Some of the answers to this question are simple and self-evident. Like many communities, R. A. P. S. was created in part out of a need to connect with others of similar interests. Donna's original letter proposed that potential members should be artists "who are also interested in, not necessarily proficient at, carving stamps." Carving stamps is obviously not an art form with an exceptionally large following. Because of the limited number of artists practicing this form, stamp carvers are isolated from their fellows by great distances. June Munger mentioned that a move from California to Colorado in 1986 separated her from a close group of artist friends (many now R. A. P. S. members) and felt that R. A. P. S. had "somewhat restored" this camaraderie.

But connecting with others of shared interests is too simple an answer. What motivates many R. A. P. S. members to join and continue their association with the project is a deeper commitment to integrate art into their lives on every level. In

"Modern Arts and Arcane Concepts: Expanding Folk Art Study," Michael Owen Jones states, "The aesthetic impulse is pervasive in the lives of all of us. The structure and order of arrangements, the economy and efficiency of motion, the perfection of form that results from the skillful manipulation of raw materials in the making of pleasing and useful objects contribute to our physical survival by helping us function. We also derive intellectual pleasure, and sometimes a sense of self-worth and self-esteem from our ability to perfect form. And contemplating a well-made object or beautifully executed performance . . . can be spiritually elevating and enriching to our lives no matter how fleeting the moment or seemingly 'ordinary' the object or activity" (1987:81).

While R. A. P. S. members form a diverse group whose occupations run the gamut from dental hygienist to yo-yo artist and magician, and whose ages range from twenty-three to sixty, they all seem to share a common belief in the value and importance of art. R. A. P. S., in this context, became an affirmation of this value among people who espoused it as well as a facet of their individual and collective efforts to nurture the creative impulse. Vicki Timmons describes it this way:

> I think that the ultimate community would be a community that doesn't view your art as painting, drawing, music, but that wherever your passion is,

"Self-portrait with perm—eek!" by June Munger.

Carved stamp image by Dianne Jenkins.

that's your art. And if you happen to be going through a divorce, and that's your passion to get through the divorce, then that's your art, that's your medium. Your work of art is how healthily you come through it. . . . And whether it be relationships or mathematics or laying out the city streets or finding a clever sentencing for a criminal that will be healing for the community and expanding for the criminal; a culture for the arts is I guess what I am looking for.

We aren't valued in this world, in this country . . . unless you get a lot of money for it. . . . That's why people give away their lives for forty hours a week or sixty or eighty and they end up in retirement and in old age and unhealthy with a broken heart and not the will to live and no interest in life because they didn't realize in playing that game they sold their soul and there was no time for art. They forgot what art was. "Oh yeah, I remember art. Don't you find that in museums?" And they forgot that the art was in their heart and art has to be expressed, art has to be felt, seen, tasted somehow, expressed and experienced in the senses. . . .

R. A. P. S. is a community constructed by means of possibly intimate yet limited regular communication and consisting of a relatively stable group of people with a shared interest in carving stamps and a shared belief in the primacy of art in human existence. The stability of the group creates safety that perhaps allows for the possibility of intimacy across great distances of time and space. Reaching across spatial and temporal boundaries to connect with others through their creative works, R. A. P. S. members have sought to bridge separations (plate 44) while at the same time maintaining them. In so doing they nurture the beauty and meaning that some call art, that Vicki Timmons calls life. Perhaps partly because of this desire to reaffirm the integration of art into daily life, these artists have embraced terminology that associates their art with the playful or mundane. The term "R. A. P. S.," however, also suggests something else. In its colloquial usage, "raps" refers to flowing, unencumbered conversations. R. A. S. members strive to cultivate not only connections between art and life but also connections with each other. In the course of our lives, a meeting once every two months by post may not seem very connected, but the dedication with which members fulfill their creative commitment to the group indicates otherwise. Whatever the reasons, the correspon*dance* of R. A. P. S. members will continue. Like the letter carrier who bears the artists' precious cargo every two months, neither rain nor sleet nor snow will keep them from it. See you in the mail.

Carved stamp image by the author.

Resources

The following list is limited to some of the companies and publications referred to in the text and is not intended to be comprehensive. Interested readers are encouraged to refer to either of the two periodicals below for further information on rubber stamp and mail art resources. Most mail order companies charge a fee for catalogs. Call or write for details.

Periodicals

Rubberstampmadness
408 SW Monroe #210
Corvallis, OR 97330
(503) 752-0075

National Stampagraphic
 Editorial Office
 1952 Everett Street
 N. Valley Stream, NY 11580

 Subscriptions
 19652 Sacramento Lane
 Huntington Beach, CA 92646-3223
 (714) 968-4446

Rubber Stamp Companies and Stores

A Stamp in the Hand Company
(mail order retail and wholesale; retail stores; organizers of the Original Rubber Stamp Convention and Stampfest Summer Retreat)
 General Office
 20630 S. Leapwood Avenue, Suite B
 Carson, CA 90716
 (310) 329-8555
 FAX: (310) 329-8985
 FAX outside California (domestic):
 (800) 299-8985

 Del Amo Fashion Center Store
 3525 Carson St. Space 143
 Torrance, CA 90503
 (310) 793-9482

Clearsnap, Inc.
(mail order retail and wholesale)
P.O. Box 98
Anacortes, WA 98221
(800) 448-4862
FAX: (360) 293-6699

Museum of Modern Rubber
(mail order retail and wholesale)
3015 Glendale Blvd.
Suite 100C
Los Angeles, CA 90039
Phone & FAX: (213) 662-1133

Neato Stuff
(mail order retail and wholesale)
P.O. Box 4066
Carson City, NV 89702

Paper Post
(retail store only)
1145 Lindero Canyon Road #D3
Thousand Oaks, CA 91362
(818) 865-0702

Stamp Francisco/The Stampart Gallery/
The Rubber Stamp Museum
(mail order retail and wholesale; retail
store; gallery/museum)
466 Eighth Street
San Francisco, CA 94103
Phone & FAX: (415) 252-5975

Stampa Barbara
(mail order retail, no catalog; retail stores)
 Paseo Nuevo Store
 505 Paseo Nuevo
 Santa Barbara, CA 93101
 (805) 962-4077

 Crystal Court Store
 3333 Bear Street
 Costa Mesa, CA 92626
 (714) 546-3333

 Melrose Store
 6903 Melrose Avenue
 Los Angeles, CA 90038
 (213) 931-7808

Stampscapes
(mail order retail and wholesale)
7451 Warner Avenue Suite E #124
Huntington Beach, CA 92647

Other Resources

Carving Stamps
(16-page instructional book by Julie Bloch,
$5 postage paid)
51 Mongaup Road
Hurleyville, NY 12747

Rubberstampers e-mail list
(To subscribe, send e-mail to the address
below. Body of message should read:
Subscribe rubberstampers <your e-mail
address>. Subscribe only if prepared
to receive numerous postings daily.)
majordomo@list.genie.com

Rubberstampers newsgroup
Rec.crafts.rubberstamps

Write to the author in care of University
Press of Mississippi, 3825 Ridgewood Road,
Jackson, MS 39211

References

Babcock, Barbara, Guy Monthan, and Doris Monthan. 1986. *The Pueblo Storyteller: Development of a Figurative Ceramic Tradition.* Tucson: University of Arizona Press.

Bantock, Nick. 1993. *The Golden Mean.* San Francisco: Chronicle Books.

———. 1992. *Sabine's Notebook.* San Francisco: Chronicle Books.

———. 1991. *Griffin and Sabine.* San Francisco: Chronicle Books.

Bronner, Simon J. 1986. *American Folklore Studies: An Intellectual History.* Lawrence: University Press of Kansas.

Burdick, J. R. 1964. *Pioneer Postcards.* Franklin Square: Nostalgia Press.

California Brand Book. 1987. Sacramento: Department of Food and Agriculture, Division of Animal Husbandry and Bureau of Livestock Identification.

Carrion, Ulises. 1980. *Stempelkunst in Nederland.* Amsterdam: Stempelplaats.

Chattopadhyay, Kamaladevi. [1975] 1985. *Handicrafts of India.* New Delhi: Indian Council for Cultural Relations, Indraprastha Press.

Crane, Michael. 1984. "A Definition of Correspondence Art" and "The Origins of Correspondence Art." In *Correspondence Art,* Michael Crane and Mary Stofflet, 3–37 and 83–116, respectively. San Francisco: Contemporary Arts Press.

Douglass, Sue Nan. 1989. "Carving Made Simple." *Rubberstampmadness* 45:5–7.

———. 1986. "The Ins and Outs of Eraser Carving." *Rubberstampmadness* 37:16–17.

Ferrero, Pat, Elaine Hedges, and Julie Silber. 1987. *Hearts and Hands: The Influence of Women and Quilts on American Society.* San Francisco: The Quilt Digest Press.

Fick, Carolyn E. 1990. *The Making of Haiti: The Saint Domingue Revolution from Below.* Knoxville: The University of Tennessee Press.

Field, Frederick V. 1967. *Thoughts on the Meaning and Use of Pre-Hispanic Mexican Sellos.* Vol. 3, *Studies in Pre-Columbian Art and Archeology.* Washington D. C.: Trustees for Harvard University.

Fiske, John. 1989. *Understanding Popular Culture.* New York: Routledge.

Friedman, Ken. 1995. "Foreword: The Eternal Network." In *Eternal Network: A Mail Art Anthology,* edited by Chuck Welch. Calgary: University of Calgary Press.

Galavaris, George. 1970. *Bread and the Liturgy: The Symbolism of Early Christian and Byzantine Bread Stamps.* Madison: The University of Wisconsin Press.

Hall, Laurel. 1994. "Betty Harris." *Rubberstampmadness* 75:25.

Hammond, Joyce D. 1986. "Polynesian Women and Tifaifai: Fabrications of Identity." *Journal of American Folklore* 99:259–79.

Held, John Jr. 1991. *Mail Art: An Annotated Bibliography.* Metuchen: The Scarecrow Press, Inc.

Held, John, Jr., and Picasso Gaglione. 1995. *The Fake Picabia Brothers in L'Art Tampon: A Rubber Stamp Performance.* San Francisco: Stamp Art Editions.

Jedlicka, Judith A. 1982. "Early American Splint Baskets." In *Americana: Folk and Decorative Art,* edited by Art and Antiques. New York: Billboard Publications, Inc.

Jones, Michael Owen. 1989. *Craftsman of the Cumberlands: Tradition and Creativity.* Lexington: The University Press of Kentucky.

———. 1987. *Exploring Folk Art: Twenty Years of*

44

Thought on Craft, Work, and Aesthetics. Ann Arbor: UMI Research Press.

Lee, Ruth Webb. 1952. *A History of Valentines.* Wellesley Hills: Lee Publications.

Lichtman, Robert. Undated. Untitled, unpublished manuscript.

List, S. K. 1987. "Zen and the Art of Rubber Stamp Carving." *Rubberstampmadness* 36:30–31.

Mail Art Magazine Listings. 1994. *Netshaker.* May: 1.

Meyers, James. 1992. "Nonmainstream Body Modification: Genital Piercing, Branding, Burning, and Cutting." *Journal of Contemporary Ethnography* 21:267–306.

Miller, Joni K., and Lowry Thompson. 1978. *The Rubber Stamp Album: The complete guide to making everything prettier, weirder, and funnier. How and where to buy over 5,000 stamps. And how to use them.* New York: Workman Publishing.

Moran, James. 1973. *Printing Presses: History and Development from the Fifteenth Century to Modern Times.* Los Angeles: University of California Press.

Neumark, Naomi. 1992. "The Evolution of Stamp Francisco." *Rubberstampmadness* 61:44–45.

Noveck, Madeline. 1975. *The Mark of Ancient Man—Ancient Near Eastern Stamp Seals and Cylinder Seals: The Gorelick Collection.* Brooklyn: The Brooklyn Museum.

Perneczky, Géza. 1993. *The Magazine Network: The Trends of Alternative Art in the Light of Their Periodicals 1968–1988.* Köln: Soft Geometry.

Peterson, Sally. 1988. "Translating Experience and the Reading of a Story Cloth." *Journal of American Folklore* 101:6–22.

Schaffner, Cynthia V. A., and Susan Klein. 1984. *Folk Hearts: A Celebration of the Heart Motif in American Folk Art.* New York: Alfred A. Knopf.

Turner, Victor. [1969] 1977. *The Ritual Process: Structure and Anti-Structure.* Ithaca: Cornell University Press.

Trejo, John "Puppet." 1992. *Imagery in Motion.* Long Beach: Homeland Cultural Center.

Welch, Chuck. 1986. *Networking Currents: Contemporary Mail Art Subjects and Issues.* Boston: Sandbar Willow Press.

Zabitsky, Freya. 1989. "Educating Larry." *Rubberstampmadness* 45:18–21.

Interviews

Except for the interview with Darryl Butler, which took place in the summer of 1995, interviews were conducted in spring and summer of 1994. In order to maintain consistency with information gathered during the interview process, ages cited in the text reflect this time period and were not changed.

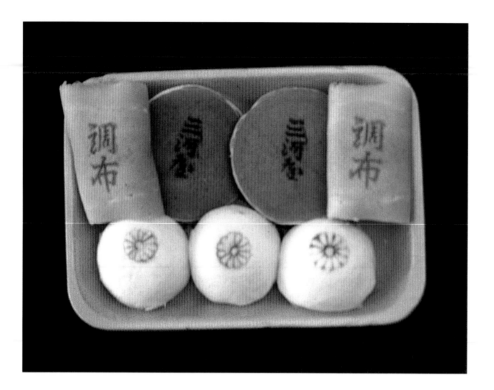

PLATE 1
An assortment of
stamped sweets from
Mikawaya Sweet Shop.

46

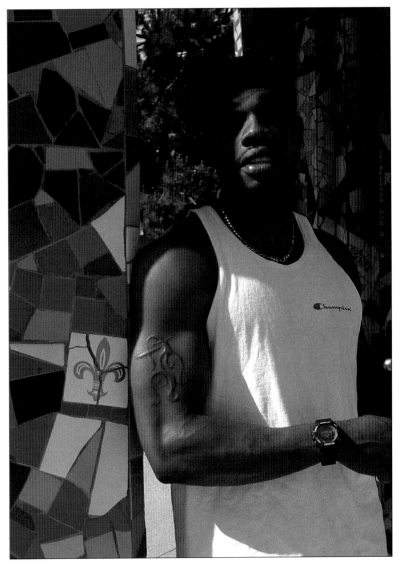

P L A T E 2
Darryl Butler, graduate member of the Omega Psi Phi fraternity (originally from the Nu Psi chapter in Virginia), with fraternity symbol on right bicep. The symbol consists of omegas interlaced with lightning bolts: "Sons of blood and thunder."

PLATE 3
Seamless panorama
created with stamps
from Stampscapes.

49

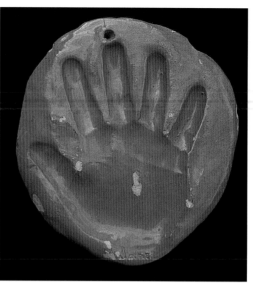

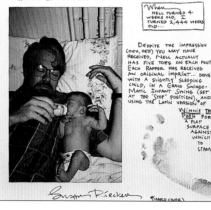

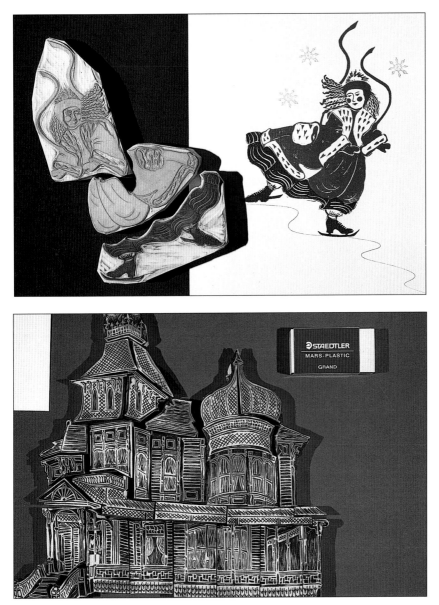

P L A T E 9
Interlocking image carved
by Sue Nan Douglass
from three Staedtler
Mars Grand erasers.

P L A T E 1 0
Expanded image of a
house carved by Don
Nelson from erasers.

51

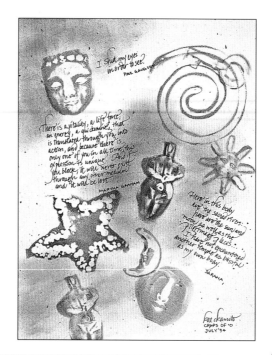

PLATE 11
A page by Kat Okamoto from R. A. P. S., vol. 2, no. 6. Stamped images were made with jewelry pieces pushed into heated Penscore, then inked with Marvy brush markers and imprinted onto paper.

PLATE 12
Envelope sent to David Jones in 1980 depicting hand-drawn comic book heroes.

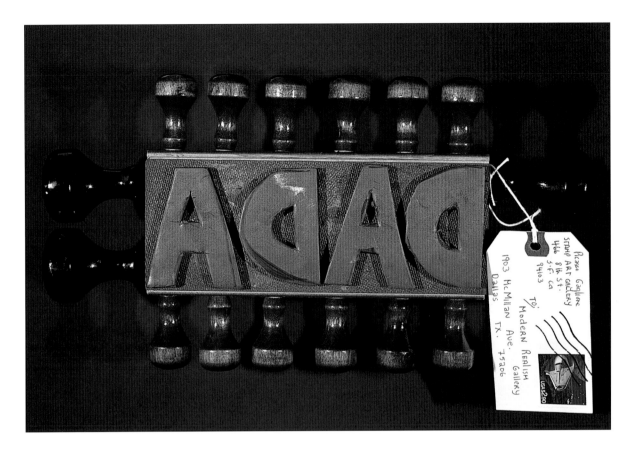

P L A T E 1 3
A rubber stamp sculpture
created by Picasso Gag-
lione and mailed as is
from California to Texas

53

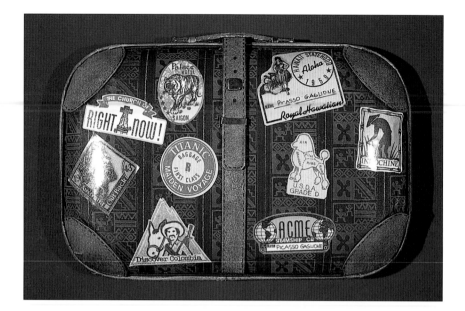

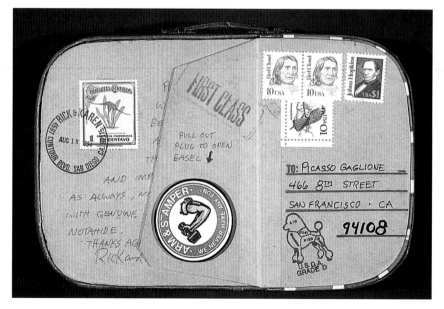

P L A T E 1 4
Rubber-stamped three-dimensional suitcase/postcard by Rick and Karen. From the archive of Picasso Gaglione.

P L A T E 1 5
Reverse side of "suitcase" bears address, postage, and stand for display.

THE THREE GRACES

NOT MARBLE, NOR THE GILDED MONUMENTS

NOT MARBLE, NOR THE GILDED MONUMENTS
OF PRINCES SHALL OUTLIVE THIS POWERFUL RHYME;
BUT YOU SHALL SHINE MORE BRIGHT IN THESE CONTENTS
THAN UNSWEPT STONE BESMEARED WITH SLUTTISH TIME.
WHEN WASTEFUL WAR SHALL STATUES OVERTURN,
AND BROILS ROOT OUT THE WORK OF MASONRY,
NOT MARS HIS SWORD NOR WAR'S QUICK FIRE SHALL BURN
THE LIVING RECORD OF YOUR MEMORY.
'GAINST DEATH AND ALL OBLIVIOUS ENMITY
SHALL YOU PACE FORTH; YOUR PRAISE SHALL STILL FIND ROOM
EVEN IN THE EYES OF ALL POSTERITY
THAT WEAR THIS WORLD OUT TO THE ENDING DOOM.
SO, TILL THE JUDGEMENT THAT YOURSELF ARISE,
YOU LIVE IN THIS, AND DWELL IN LOVERS' EYES.

WILLIAM SHAKESPEARE

PLATE 16
Ada B. Fine interprets the three graces in R. A. P. S., vol. 2, no. 4.

PLATE 17
Kat Okamoto's variation on the theme of the three graces in R. A. P. S., vol. 3, no. 1.

PLATE 20
India Bonham's first
R. A. P. S. page, from
vol. 1, no. 6.

PLATE 21
R. A. P. S. page by India
Bonham the following
year, from vol. 2, no. 4.

57

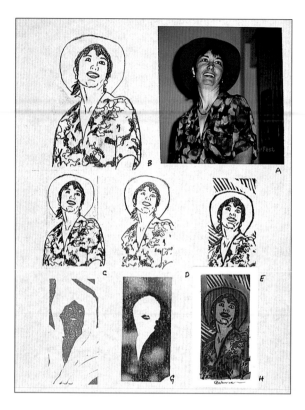

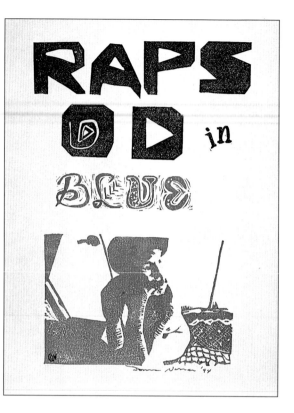

PLATE 22
R. A. P. S. page by Donna
Nassar illustrating the
process she used to
create a self-portrait from
three layered carving
blocks, vol. 2, no. 2.

PLATE 23
Self-portrait by Donna
Nassar, from R. A. P. S.,
vol. 2, no. 5.

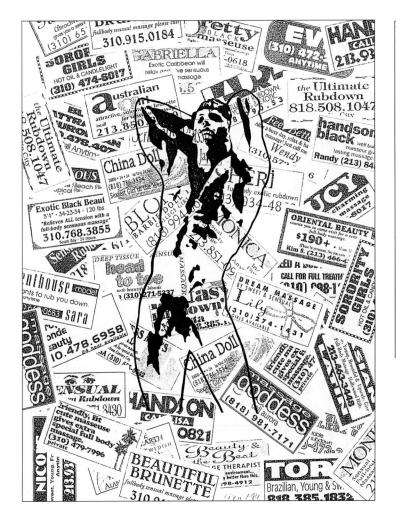

P L A T E 2 4
R. A. P. S. page by Don
Clarke shows a hand-
carved image of nude man
stamped atop Xeroxed
advertisement collage,
vol. 2, no. 6.

P L A T E 2 5
Detail of R. A. P. S. page
by Don Clarke, vol. 3,
no. 1.

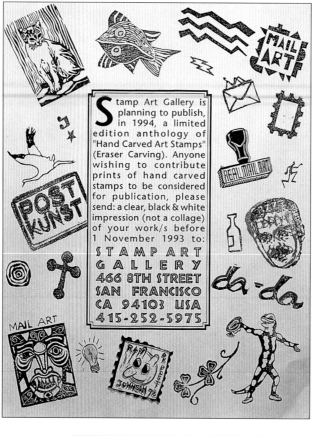

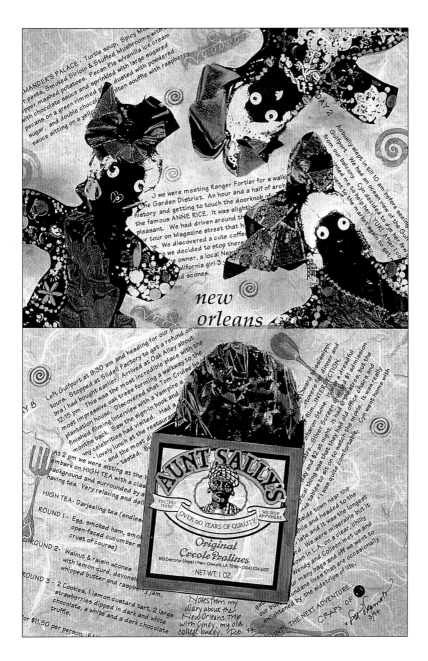

PLATES 29 – 32
Kat Okamoto at work on
an R. A. P. S. page in her
Carson, California, office:

PLATE 29
Stamping the primary
image.

PLATE 30
Stamping additional
embellishments.

62

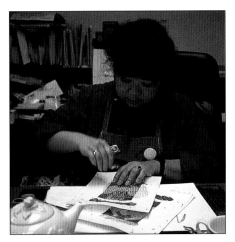

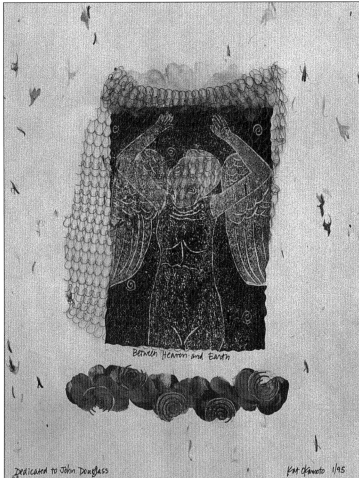

PLATE 31
Sewing on copper mesh.

PLATE 32
Finished R. A. P. S. page,
vol. 3, no. 3.

²¹/₂₃ J. Sloan '93

HERE'S MY TRIBUTE to the recent holiday. My pagan friends had a big gathering with a Gypsy theme. I cranked this out at the last minute as a gift for our hosts. It is carved in Nasco Saf-t-cut. I like the economy and size that the Nasco stuff affords me. But, I think that nothing can beat a Mars Staedler or the stuff Wendy has found for quality.

FAREWELL DONNA, GOOD LUCK DON. Kinda poetic, isn't it? I will miss Donna's editorial comments and wonderful stampings on the address page. But, I am looking forward to seeing what changes Don will bring. I hope my being a little tardy this issue wasn't to big of an inconvenience. Good luck to both of you!

FINALLY, I hope to have more written in future issues. Being back in school has left me a trifle overwhelmed. I think I am finally getting used to taking tests again! Until next time...

PLATE 33
Halloween commemorative R. A. P. S. page by Stephen Sloan, vol. 2, no. 2.

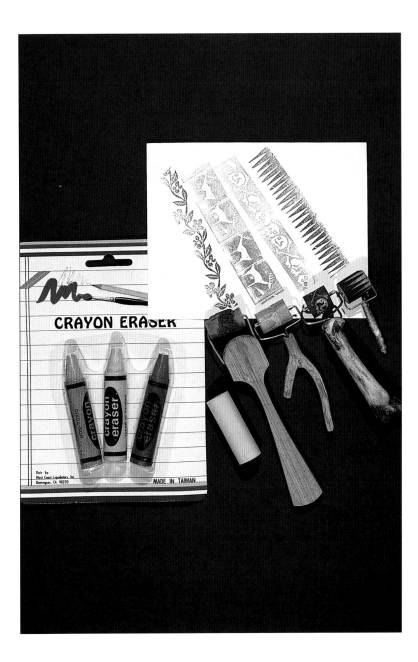

PLATE 34
Cylindrical stamps
created by Stephen Sloan
from crayon erasers and
handles of wood, bone,
and other materials.

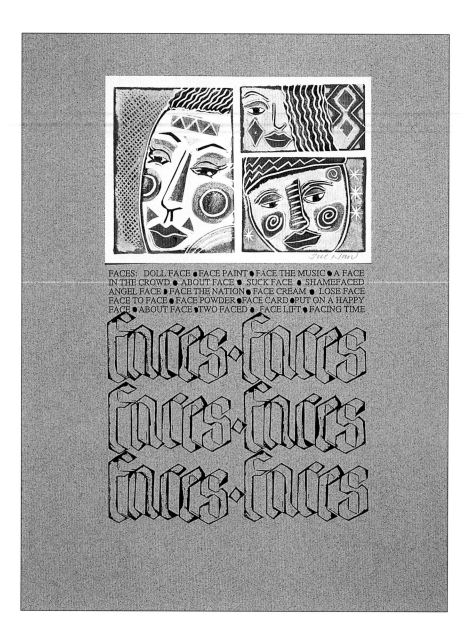

FACES: DOLL FACE • FACE PAINT • FACE THE MUSIC • A FACE IN THE CROWD • ABOUT FACE • SUCK FACE • SHAMEFACED ANGEL FACE • FACE THE NATION • FACE CREAM • LOSE FACE FACE TO FACE • FACE POWDER • FACE CARD • PUT ON A HAPPY FACE • ABOUT FACE • TWO FACED • FACE LIFT • FACING TIME

faces • faces
faces • faces
faces • faces

PLATE 35
Sue Nan Douglass displays her penchant for lists in R. A. P. S., vol. 2, no. 6.

66

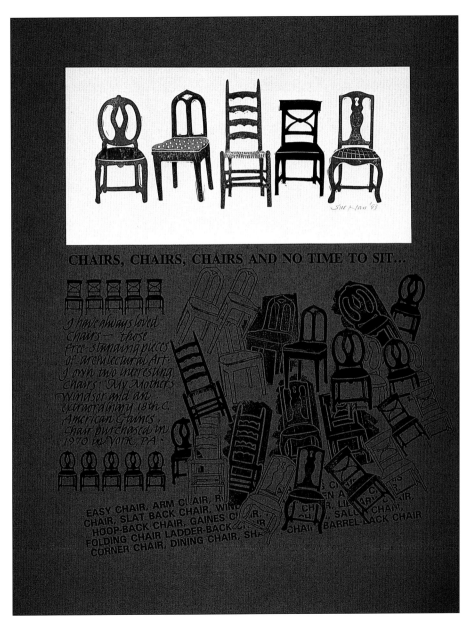

CHAIRS, CHAIRS, CHAIRS AND NO TIME TO SIT...

I have always loved chairs— those free-standing pieces of architectural Art. I own two interesting chairs: My Mother's Windsor and an extraordinary 18th C. American Gaines chair purchased in 1970 in York, PA.

EASY CHAIR, ARM CHAIR, R CHAIR, SLAT BACK CHAIR, WIN HOOP-BACK CHAIR, GAINES C FOLDING CHAIR LADDER-BACK CORNER CHAIR, DINING CHAIR, SH

PLATE 36
Sue Nan Douglass uses multiple variations on a single theme in composing her page for R. A. P. S., vol. 1, no. 5.

67

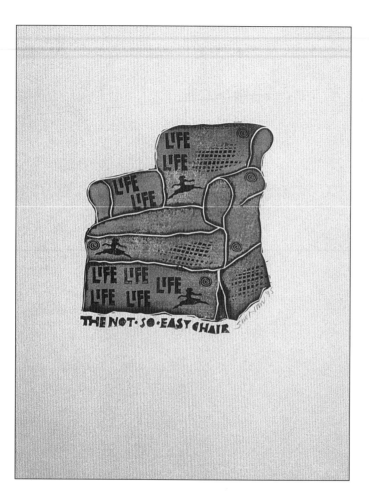

LIFE
LIFE

LIFE
LIFE

LIFE LIFE LIFE
LIFE LIFE LIFE

THE·NOT·SO·EASY CHAIR

P L A T E 3 7
Sue Nan continues with a
chair theme for R. A. P. S.,
vol. 3, no. 3.

i dream of my
H · O · M · E

P L A T E 3 8
R. A. P. S. page by Wendy
Gault, vol. 3, no. 4.

... I sink my wonder into our
sacred spiral where you and I
alone discovered how the eternal
water of life pours the essence of
the soul into the crown of the
head and flows through the heart
then swirls the double locking
spiral of inception and creation,
then is once again born into the
world. Another soul. Hope of
peace.....and that is the symbol
you are carving. It is sacred. We
must find its history.
From a treasured letter from Vicki to me, Wendy

P L A T E 3 9
When they first met,
Vicki Timmons brought
Wendy Gault to this non-
functioning fountain at La
Casa de Maria Retreat
Center in Santa Barbara,
California.

P L A T E 4 0
In tribute to their friend-
ship, Wendy based her
R. A. P. S. contribution
in vol. 2, no. 1, on the
fountain.

PLATE 41
Detail from R. A. P. S.
page by Larry Angelo,
vol. 1, no. 4.

PLATE 42
R. A. P. S. page by Vicki
Timmons from vol. 3,
no. 4.

P L A T E 4 3
R. A. P. S. page by Vicki
Timmons from vol. 2,
no. 2.

P L A T E 4 4
R. A. P. S. page by Judi
Donin from vol. 2, no. 5.